WITNESS TO HISTORY

THE PHOTOGRAPHS OF

YEVGENY KHALDEI

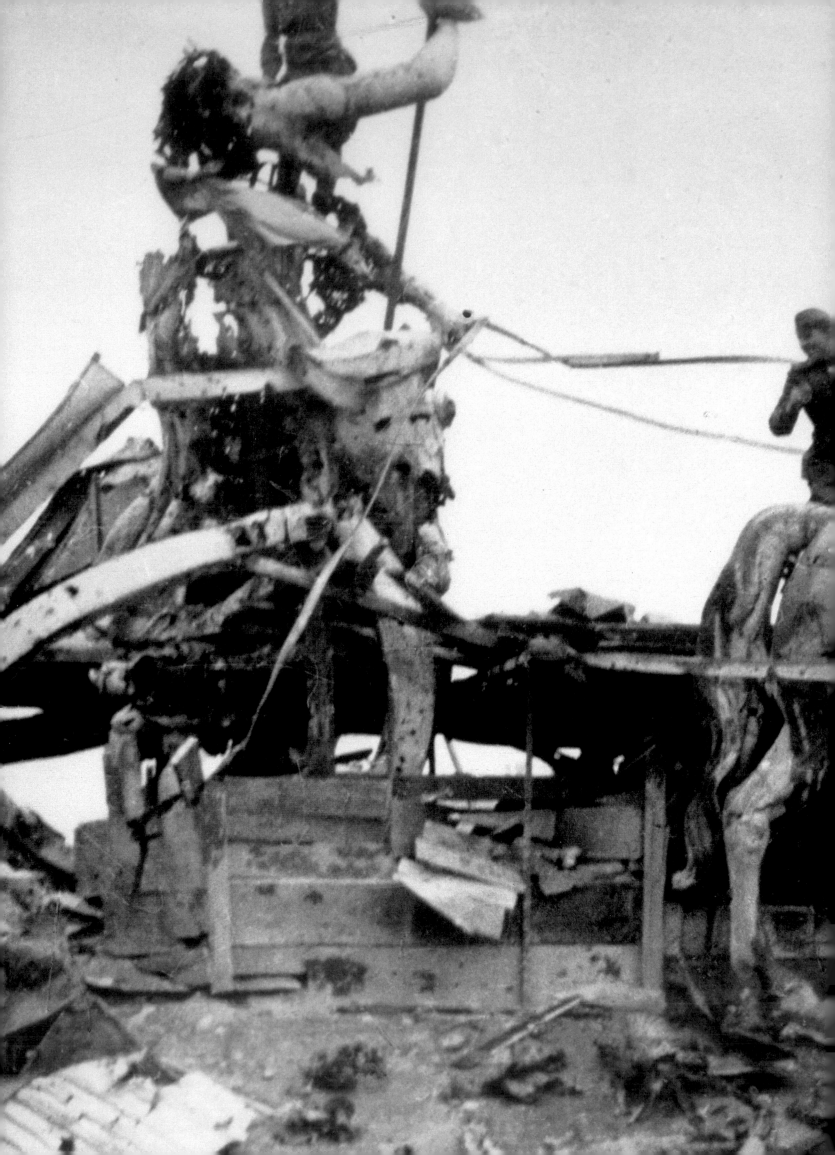

WITNESS TO HISTORY

THE PHOTOGRAPHS OF
YEVGENY KHALDEI

BIOGRAPHICAL ESSAY BY
ALEXANDER AND ALICE NAKHIMOVSKY

YEVGENY KHALDEI, WHOSE STRIKING IMAGES CAPTURED HALF A CENTURY OF SOVIET HISTORY, HAS LIVED A SOVIET LIFE OF HARDSHIP, HUMILIATION, AND GREATNESS. HE BEGAN WITH HUGE NATURAL GIFTS AND VIRTUALLY NO FORMAL EDUCATION. IT WAS THE SOCIAL DYNAMISM OF THE EARLY SOVIET STATE, ITS THIRST for new talent, that brought him from the provinces to the center of Moscow. At the time, his Jewish background was immaterial. Later, after his photographs of Russia at war had brought him fame, the Soviet state rediscovered anti-Semitism. Khaldei, who had lost his entire family in the war, was now ousted from his job as well.

His early photographs reflected popular beliefs and styles. It was World War II, paradoxically, that brought him artistic freedom. Khaldei covered the war from Murmansk to Sevastopol, from Moscow to Berlin. He decided what he would photograph and, to a surprising degree, where he would go. His photographs attained an iconographic power: his were the images that shaped how people remembered history. But particularly in the West, where Khaldei's work was attributed to an anonymous "Sovfoto," few people knew who he was. At the end of the Soviet era, Khaldei was living in poverty in Moscow, in a room crammed with enlargers and a priceless archive.

The dissolution of the Soviet Union was followed four years later by the fiftieth anniversary of the Allied victory. The confluence of these events, and the efforts of supporters on two continents, returned Khaldei to the public eye. Now, in the absence of the Soviet state, his photographs remain as witness to its tragic contradictions.

BEFORE MOSCOW Khaldei was born in Yuzovka (later Stalino, still later, Donetsk), an industrial town in the Ukrainian Donbass, on March 10, 1917. In November of that year came the Bolshevik Revolution, and within months, a civil war. Ukraine was hit hard, but the brunt of savagery was borne, as it had been so often before, by the Jews. During a pogrom in Yuzovka, Khaldei's mother was shot and killed. She died trying to protect her son: the same bullet that took her life came to rest in his body. He was just one year old.

The young Khaldei was brought up by his grandparents. In a photograph of 1940, we can see their house (below): one room, no plumbing. But the poverty was countered, in typical Jewish style, by education or at least the desire for it. When not thwarted by tragedy, there was forward movement: this was not the static poverty of peasants. His father was a musician and Khaldei studied violin. At home, his grandfather taught children the fundamentals of Yiddish literacy (teaching Hebrew was by then forbidden); Khaldei was there during these lessons.

From the world outside came magazines—*Ogonyok, Krasnaya Niva, Prozhektor*—with photographs of the USSR under construction. Here was the march of modern life, couched in a modernist esthetic of odd angles and outsized workers. Khaldei was fascinated: "The event was over, but the photograph remained." The profession of photojournalism was just beginning, and he wanted to join it. But before he could capture events, events, in a sense, captured him.

Collectivization struck Ukraine in the early months of 1930, accompanied by deportations of recalcitrant, or rich, or simply random peasant families, and by a famine so profound—five million died—as to be termed genocidal. The worst of the famine was in the countryside, but the cities were also in trouble. In order to

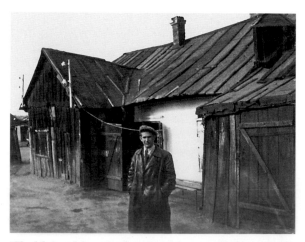

Khaldei at his grandparents' house, Stalino, 1940

feed himself, Khaldei left school. He had completed four grades, and, with the exception of a brief photography course in Moscow, that was all the formal education he would ever receive.

Lying about his age, Khaldei got work in the railroad shop of a steel factory. He was small—his job was to crawl inside steam engines and clean them. In return he was given a ration card for 800 grams of bread, half of which he sold. Through all of this, he did not forget photography. In 1932, working from a diagram in a magazine, he built himself a camera from a cardboard box and his grandmother's spectacles. Across the street was a church, which was beautiful, and more to the point, immobile. He started taking pictures of it.

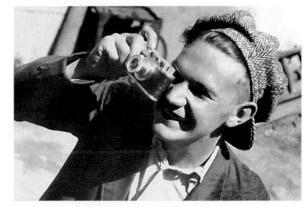

Khaldei with his FED camera, Stalino, 1933

Khaldei's homemade camera was shortly followed by two real ones. The first came from a bank, one of the rewards that the state offered to depositors, to discourage them from hoarding their money at home. Every month, Khaldei brought in a hundred rubles; in 1933 he was invited to collect his camera in a beautiful leather case. The second, already more professional, was a FED, the Soviet-made Leica (it can be seen in Khaldei's hand, top right). The initials belonged to Felix Edmundovich Dzerzhinsky, head of the secret police, and the product was, indeed, manufactured in a youth colony under the watchful eye of that dubi-

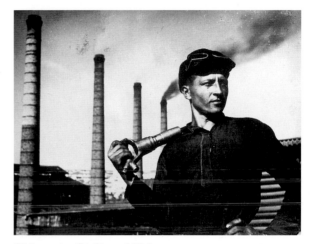

Chimneys, Stalino, 1934

ous service. (Later, TASS would outfit Khaldei with a genuine Leica; it remained with him throughout the war, until the photographer Robert Capa presented him with a Speed Graphic.)

Armed with a working camera, Khaldei began contributing to his factory newspaper and then to city and regional publications. His first published photograph shows a mighty worker on a factory roof (bottom right). The seventeen-year-old Khaldei had created an image of precise formal balance, assimilating the style and symbolism of the era of industrialization.

In addition to rooftops, the young correspondent saw the countryside, where collectivization was still in progress. Groups of people would be sent on propaganda missions: an accordionist, a filmmaker, a Party lecturer, and the photographer Khaldei. This was Khaldei's initiation into political ambiguity—peasants were still being arrested, but like the filmmaker and the accordionist, Khaldei celebrated utopia in the making. Remaining from those visits is an image of a man flanked by two powerful-looking cows (Khaldei had some trouble with the cows, which, unlike the worker or the local church, refused to stand still). Another set of symbols stands behind an image of Pasha Angelina, woman tractor driver: taking a break from her plowing, she sits in the driver's seat and studies a volume of Marx.

By 1935, Khaldei was ready to move on. He put together a box of glass negatives and sent them to Moscow, to Fotokhronika of Soyuzfoto, the precursor of the wire service TASS. Prints were made and published, and the photographer was invited to the capital for a professional course. He studied with the master photographers of the period, Semyon Fridlyand, Arkady Shaikhet, and Max Alpert, and was given lessons in chemistry. When his course was over, he returned to Stalino, but his mind remained on Moscow.

MOSCOW: 1936–1941 Khaldei had been promised a job with Fotokhronika. His problem was getting housing, and with it, the all-important Moscow residence permit. Unsuccessful on both counts, but too embarrassed to return to Stalino, he contacted a man named Syrkin, the editor of *Sotsialisticheskii Donbass*. Syrkin, for whom Khaldei had worked before, was on his way to Chelyabinsk and Khaldei asked if he could come along. At the last minute Khaldei backed out, which was fortunate for him: *Socialist Donbass* had fallen out of favor, and Syrkin was arrested along with his entire editorial staff. It was 1936, the start of the Terror—the mass arrests of political activists, intellectuals, and numerous others—which began to wane only in 1939.

Khaldei's father had a friend in Moscow, a tailor named Israil Solomonovich Kishitser. Kishitser would later sew the flag that Khaldei photographed over the Reichstag. Kishitser had a friend who was a Russian (as opposed to Jewish) tailor, and this friend had a client who ran the famous Sandonetsky Baths. Among the habitués of that establishment was the head of the passport division, responsible for residency stamps. After a visit and a few beers, Khaldei had what he needed. He rented a corner of a room from a family with six children, who lived there as well. Eventually, he moved in with the Kishitsers.

Khaldei's work for TASS was interrupted when he was drafted in 1937. Serving as a guard on the Finnish border, he was demobilized just in time to avoid the Soviet incursion into Finland (November 1939 to March 1940). In the early days of that war, the unit he had been with was wiped out.

Khaldei did observe the other major Soviet event of late 1939. Back with TASS, he covered the aftermath of what the Soviet press euphemistically referred to as "the liberation of the western regions of Belorussia and Ukraine." In Bialystok, formerly Poland, Khaldei saw something he did not expect: the massive involvement of the NKVD—the secret police—in deporting refugees.

It was monstrous. . . . Our soldiers were expelling refugees from Warsaw, from the war with the Nazis. In a single night 50,000 were expelled. An NKVD major or general told us, "All of you are now mobilized. You will help us exile the whole lot of them to the Tatars." You know, to Central Asia, to Siberia. I saw what was happening right there: there were two families, and soldiers appeared and grabbed whatever bags they had with them, and threw them into trains. There was screaming

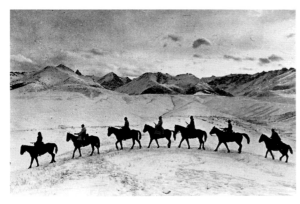

Red Army soldiers, Russian-Chinese border, 1940

and moaning. It was a tragedy. I couldn't take it—I ran away. I was staying with a photographer, Iosif-Aronovich Rabinovich. I rang at his door, but he didn't want to open up. He said, "You ought to be ashamed of yourselves, we were expecting so much from you, from Soviet power. . . ."

In sharp contrast to the mood of Khaldei's story are two photographs from the same period (this page and opposite). The Red Army soldiers (left) were patrolling the border between China and Soviet Kirgizia. Poised in a perfect arc in this image, they project serenity. (As it happened, the Chinese border would not need much patrolling.) The women in the photograph opposite are from Eastern Poland, after its "liberation." Smiling as they go off, barefoot, to build a canal, they seem to have made a seamless transition into the world of Socialist Realism.

But the war was getting close. Russians both acknowledged and dismissed the threat. While danger signals were abundant—in the fall of Poland, Holland, France, and the battle of Britain—those who sought reassurance could find it in the recently signed Stalin-Hitler pact and the expanded Soviet borders that resulted from it.

Newspapers stressed Soviet security based on military strength and Stalin's diplomatic skill. People who thought otherwise kept their speculations private.

In this interval, Khaldei made a trip home to Stalino. The photographs he took—of his grandparents, and of his father with his sisters and half-sisters (page 8)—were the last he would take of them. The Nazis entered Stalino in October, 1941. Khaldei's family, along with the rest of Stalino's Jews, were shot and thrown down a mine shaft.

THE WAR IN RUSSIA: MURMANSK AND THE SOUTH It was a sunny Saturday, June 21, 1941, the centennial of the poet Mikhail Lermontov's death. Khaldei was in Tarkhany, the small town in central Russia that was Lermontov's birthplace. Children were gathered for an outdoor reading of his poetry, and Khaldei photographed them, standing in their white shirts under leafy trees.

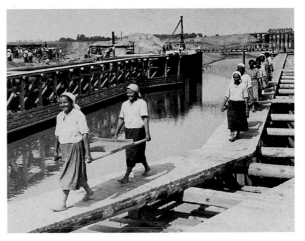

Eastern Poland, 1940

At four o'clock the next morning, the Nazis invaded. There was no public announcement of this until 12:00 noon, but to Khaldei, on his way home from the Moscow train station, the signs were ominous:

I was living at Number 12 Leontievsky Street. The German embassy was right there. They were loading up trucks—there were bags lying all over the place. I understood something had happened. I said to Kishitser, "Let us go to the baths." When we came back it was the same scene, and when we walked in his wife said, "Somebody called you from Fotokhronika. It's urgent, you have to get there right away." We understood, but were afraid even to hint to each other. Everyone was afraid of even thinking out loud.

At 12 noon Molotov was going to speak. Molotov had a stutter, and now he stuttered even more, and he said what had happened. It was indescribable. I had seen a crowd gathering. We were in the TASS building and across the street people were gathering, because TASS had loudspeakers on the roof. I went outside and quietly pressed the shutter.

Within days, Khaldei was off to the Murmansk front. Nobody at TASS, or anywhere else, knew what the country was in for. His boss would give him only five hundred meters of film, enough for a week ("By that time, it will all be over").

Officially Khaldei was a Navy lieutenant, but—contrary to what has been reported about him—he did not do any fighting. A young man with only four years of schooling would hardly have been made an officer that early in the war—more preposterous still is the idea that a roving photographer could be part of a command structure, reporting to a captain somewhere and giving orders to others. Khaldei's rank gave him respect and, more important, mobility. It's one thing when a soldier tries to hitchhike, quite another when a lieutenant does; in the course of the war, Khaldei did a great deal of hitchhiking.

The singular feature of Khaldei's wartime experience was his freedom. TASS gave him travel documents and a general destination, but from there, he made his own moves. He would arrive at headquarters, get coupons for food, and decide what to do next. He often traveled with a film crew because they had a jeep. Everyone was happy to help: in wartime Russia, people wanted their stories told.

The war brought an end to many prewar restrictions. Gone was the dichotomy of earlier years, when Khaldei saw one reality and photographed another. The moment war was announced, he was able to portray individuals in a state of tension and dis-

tress, to show not only heroism when it arose, but also grief, death, frivolity, and simply endurance. For the duration of the war (but not after), the imposed ideal of socialism was eclipsed by needs that were more urgent, and far more broadly shared.

Khaldei's Murmansk pictures are somber. Compare the cloaked soldiers of *Reconnaissance mission* (pages 18–19) with the prewar cavalrymen on the Kirgiz border

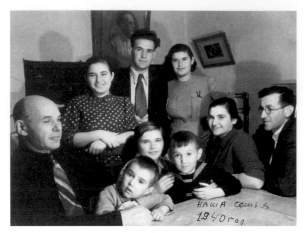

Family portrait, Stalino, 1940

(page 6). In each case, Khaldei has singled out a line of silhouettes against a broad expanse of natural space. But the ordinary daylight of Kirgizia is replaced in Murmansk by the stark contrasts of an Arctic white night. The Murmansk soldiers are dark, doubly so because of their reflections. Khaldei, anticipating the image he wanted, asked them to walk past the water.

Reconnaissance mission raises a question: to what extent did Khaldei influence the events he was documenting? In a sense, any documentary photographer chooses and frames. Soviet practice allowed more latitude. By definition, Socialist Realism called for the depiction of life "not as it is"—the method of old-style "critical" realism—but as it *ought* to be. The methodology was intended for literature and the visual arts, but the blurring of boundaries between real and ideal affected photojournalism, and print journalism as well. In his own war photographs, Khaldei's famous contemporary Dmitry Baltermants often replaced an everyday sky with a more "appropriate" dramatic one. Khaldei followed the practice, though by no means always. The lowering sky of the Nuremberg cityscape on pages 86–87 is not the product of any effect other than patience.

One photograph that is a composite is *Reindeer, Murmansk* (pages 20–21). Even while admitting this, Khaldei is insistent on the underlying veracity of his image. There *was* in fact a reindeer; it showed up during air raids. When he shows the photograph, Khaldei tells a story about it that roots it in real life:

During the bombings, a reindeer came out of the tundra. He wanted to be with people. They built him a shed to live in, and gave him a name, Yasha. Every time the alarm sounded, he ran to be with the soldiers—he didn't want to be alone. During one of the air raids, I took this shot. In 1944, when the battle for Murmansk was over, the soldiers didn't know what to do with him. They loaded him into a truck and took him back to the tundra, thinking he would join the other deer. But he couldn't understand what was happening. He ran after the truck as long as he could.

From Murmansk, Khaldei went to the south, where the fighting was heavy and protracted. In the devastating summer of 1942, the Nazis had captured Rostov and the Crimean ports of Sevastopol and Kerch. They got as far east as Novorossiisk, but there the lines were drawn. In February of 1943, the Russians established a beachhead just south of the city, overlooking the bay. They held it through the following fall, when Novorossiisk and the whole Taman peninsula were retaken.

Khaldei made a night landing onto this beachhead, climbing up a cliff under German shelling. But the morning, to his astonishment, was quiet. The combatants had got used to each other, tacitly permitting lulls in the fighting at predictable times of day. This peculiarity explains some of the photographs that Khaldei took there. The soldier on pages 36–37 could work at his sewing machine, with the reasonable expectation that he would finish his job.

The series from Novorossiisk is notable for its images of women. The sniper Liza Mironova (page 26) had just finished high school in Moscow; she did not return from the war. Female pilots are shown on pages 28–29 in a moment of lightheartedness.

Khaldei is drawn to the contrast between their courage and their vulnerability, and more generally between war and the trappings of ordinary life. At night, these women led a different life altogether:

They had light airplanes, the kind that were used for training before the war. They flew without parachutes. At night they'd climb very high, then turn off their motors so the Germans couldn't hear and drop their bombs. The Germans called them "night witches."

Also from this period are Khaldei's first images of liberation: taking a swastika down from a factory building in Kerch (page 27), basking in the sun in the ruins of Sevastopol (*Life again*, pages 38–39). Behind the images lie months of fighting, with repeated unsuccessful attempts to dislodge the Germans from their positions. Khaldei recalls:

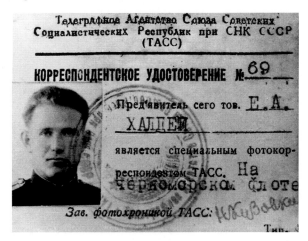

TASS identification card (in pen: Black Sea Fleet)

There was a landing at Kerch in November of '43, but the fighting went on through December, January, February, March, only in April did they take the city. For six months we were in a meat-grinder. Voroshilov came on Stalin's orders—he said, "What's the matter—why can't you take that hill? Prepare an offensive for tomorrow. If you can't do it tomorrow, then the day after tomorrow, ten o'clock." I spent the night in the trenches. In the morning the cook comes in with a pot, he says, "Good morning, I've got meat, I've got kasha, step up with your bowls." Nobody steps up. Every soldier is thinking, "What's going to happen in a half hour, during the offensive? Am I going to live, will I see my wife, my children, my parents?" I didn't take any pictures, I just couldn't. Then the offensive took place. They didn't take the hill. The dead were left on the ground. In the trench where I was staying, maybe half the men returned.

Sevastopol was in retrospect a milestone. It was liberated on May 9, 1944, one year to the day before the Russians took Berlin. Just before the liberation, Khaldei took the photograph he calls *Sky over Sevastopol* (pages 30–31). His lens was pressed against the window of an American lend-lease bomber (the other planes are Soviet). The victory at Sevastopol is represented by the mound of abandoned German helmets (page 40), and in an entirely different mode by the combination of rubble and bathers in *Life again* (pages 38–39). This particular image—one of Khaldei's favorites—was too frivolous for the Soviet censors, and though he tried repeatedly, the photographer could not exhibit it until the 1980s.

INTO EUROPE In the fall of 1944, the Red Army began its march into Europe. Khaldei documented the taking of Bucharest and Belgrade, Budapest (December to January, 1945), and then Vienna. The Soviets came as liberators, and Khaldei, in a celebratory mood, captured the exulting crowds (pages 42–45). Remarking on these images now, he always brings up the tragic disintegration of Yugoslavia and the fact that the Soviets, once so honored, would eventually be so hated. But the seed of that dissonance was also captured by his camera. In the photograph on pages 14–15, a pair of Budapest nuns walks toward a communist poster that proclaims (in Russian), "Forward under the banner of Lenin and Marshal Stalin!"

Also from Budapest come two striking images of Jews: murdered Jews in a synagogue (page 50), and a Jewish couple with haunted eyes (pages 48–49). Seeing Khaldei, they were not sure who he was or what would happen to them:

I saw them walking down the street. I was in a black leather coat, and at first they were afraid—they thought I was from the SS. I walked over and tore off their stars, first the woman's, then the man's. She got even more frightened. She said, "No, no, you can't do that, we have to wear them!" I told them that the Russians were here, I told them, "Shalom." Then she cried.

Khaldei had already documented Nazi atrocities in Rostov, where, the day before the Soviets retook the city, prisoners of war were machine-gunned in a courtyard (pages 32–33). That photograph was, of course, publishable; the image of the Jewish couple was not. The photograph of the Jews in the synagogue appears here for the first time.

Budapest was not the only place Khaldei met Jews. A much happier encounter took place outside Bucharest. There is no photograph to accompany his story (it was too dark, Khaldei says) but the tale bears repeating because of what it tells about Russians and Americans, about Russian notions of what a Jew should be and, not incidentally, about Soviet life in the field:

It was in 1944 in Romania. We were just sitting down to eat when somebody ran in and said that an American Flying Fortress had been shot down nearby and the pilots were saved and were going to have supper with us. So we immediately pulled out a few bottles of vodka and pure alcohol and waited for them. Soon a large group of big, hefty guys arrived all in lined boots and leather jackets. They were very cold. We gave them something to drink, and they sat down—thirteen of them, the whole crew of the Flying Fortress and their captain in the middle.

I was sitting next to a friend of mine, Grinya. I turned to Grinya and said, "Do you see that captain over there?" He said yes, he did, and I said, "I think he's a Jew." Grinya said, "No way, a captain of a Flying Fortress, a big guy like that? Can't be a Jew." I said, "You wanna bet?" Grinya said sure. So we bet a glass of vodka. I walked over to the captain and I said to him in Yiddish, "Du bist a yid?" His jaw dropped, and he jumped up and gave me a huge hug. Then I gave him as a present a hundred-ruble note with a picture of Lenin on it and he pulled out his wallet and took out a ten-dollar bill, and wrote something on it in Yiddish from right to left. And I told him, "You know I can speak, but I can't read any more. What did you write?" And he said, "There's no place on earth where two Jews can't find each other." Then he gave me an address in New York City, and said, "If I don't come back from the war, and you get to New York, go to this place and they will meet you the way they would meet me. And if I come home alive, and I am there, I will meet you as a friend."

The next day I was very hungry, so I sold the ten dollar bill on the black market to buy some food in Bucharest. And I never found out what happened to him.

BERLIN, FLAG OVER THE REICHSTAG Shortly before Berlin was taken, Khaldei saw Joe Rosenthal's photograph of American marines raising the stars and stripes over Iwo Jima. He vowed to do something similar in a compositional sense (photographing flag raisings was already a specialty of his). First, however, there was the matter of a flag. This was settled by a trip to Moscow and the services of his old friend, the tailor Kishitser, who sewed not one, but three flags for him. Fifty years later, after Khaldei and Rosenthal were honored together at a ceremony in Perpignan, France he would refer to their famous images as "The Revenge of Two Jews"—or three, counting Kishitser.

On the morning of May 2, the Reichstag was still burning; there was fighting going on in the basement. Khaldei raced upstairs with some soldiers. He handed them the

third and final flag (the first had been raised over Tempelhof airport, page 65, the second on the Brandenburg gate, pages 2–3). Khaldei says, "When I saw that in my viewfinder, I thought: This is what I was waiting for for fourteen-hundred days. It was scary, but I was euphoric so I didn't notice."

While Khaldei's image was published around the world, the notion of flying a flag over the Reichstag was not unique to him; there were a lot of flags and a lot of photographers. When the time came to decide who would get a medal for the deed, Khaldei's flag-raiser, Alyosha Kovalyov, was passed over. In the story Khaldei tells, he blames the slight on Stalin's dislike of Ukrainians (Alyosha turned out to be from Kiev). The honors went elsewhere, and would remain misattributed for the next fifty years.

They spent ten days deciding who should get the medal for raising the flag. Stalin said, "Let there be one Russian and one Georgian." And that's how Yegorov and Kantaria got the medals. Two years ago was the fiftieth anniversary of the victory. And the BBC, when they found out about Alyosha Kovalyov, they went to Kiev and found him and brought him to Moscow. And the BBC asked him: "Why didn't you say anything all those years, why didn't you tell them it was you and not Yegorov?" And he said: "They called me to the NKVD, and said, 'Shut up that it was you, what Stalin said is what will be. And if you start letting out that it was you in that picture, you'll be in trouble.'"

The history of the Reichstag photograph involves one final twist. As Khaldei was back in Moscow printing it, his editor at TASS noticed that the soldier holding Alyosha's feet was wearing two watches, one on each wrist. The extra watch was a sign of looting, or, at the very least, reflected an unseemly interest in consumer goods. Khaldei rubbed it out.

Khaldei took a great many photographs in Berlin. Images of victorious generals contrast with those of the vanquished. Sometimes he sees this polarity as justice achieved ("Here are the victors, and this is what happened to those who wanted to be victors"). But he also captured the sufferings of individuals and the resiliency of youth, both on the Russian side—as his friend, the poet Yevgeny Dolmatovsky, takes his turn posing with a plaster head of Hitler (page 64)—and on the German. When the air raids were over, a group of young women emerged from their hiding place underground. Khaldei made them laugh, and took their picture (page 59).

PEACE: POTSDAM AND NUREMBERG With the war over, Khaldei covered the mechanisms of peace. At Potsdam Khaldei, not yet thirty years old, found himself something of a Soviet court photographer, taking canonical pictures of Stalin in the company of Truman, Churchill, and then Atlee. He greatly admired Churchill, but Stalin was the center of his attention, both photographically (note, on pages 78–79, how the light shines on him) and anecdotally. Among Khaldei's colleagues, stories circulated about Stalin's preeminence among the Allied leaders:

Stalin always came to meetings a few minutes late. Truman and Churchill would already be there, and every time, they would get up to greet him. They started resenting it: "What are we doing getting out of our seats like schoolboys every time he walks in? Next time, let's stay put." So the next day, Stalin is late again. Truman and Churchill are busying themselves with official papers. Finally, Stalin walks in. Truman and Churchill go on shuffling their papers pretending that nothing's happening, but finally they can't take it any more, they jump up and greet Stalin. As if somebody had pricked their behinds with a pin!

Khaldei's feelings about Stalin were, and are, typical of his generation. Stalin caused unspeakable horrors; Stalin won the war. With a strong man in power, there is peace; in the absence of control, there are wars in Bosnia and Chechnya. (Despite his frequently expressed respect for Stalin, Khaldei in the post-Soviet era is a staunch and clear-sighted democrat: in the election of 1996, although he was sick, he made a point of going out and voting for Yeltsin because, he said, "the opposition was frightening"—even if Yeltsin is far from perfect.)

Not long after Potsdam came the Nuremberg trials. A new possibility at Nuremberg was having the time to think and compose. Khaldei the artist turned his eye to the city. Preparing to take *Nuremberg cityscape* (pages 86–87), he waited for hours until that moment when the sky was darker than the water. In that and other views of a nearly empty city, he found the unsettling beauty of destruction.

Another new aspect of Nuremberg was the Nazi elite, up close. Khaldei studied them, awaiting the moment when each man would reveal himself. In particular, he liked to photograph Goering. He refers to the image of Goering with his lawyer (pages 84–85) as "Goering in his cage"; the scene in full was a long corridor through which each of the accused men got his legal consultations. Goering was aware of Khaldei's attentions and resented them; Khaldei, for his part, relished their reversals in fortune:

One day I was invited to take pictures in the cafeteria. It was a small room with rough tables made out of boards. They were eating out of aluminum bowls, they had two small pieces of bread, and an American soldier was coming around with a pail and a ladle, and dumping something into those bowls. So I walked along the wall, and photographed each of them eating. Then I reached Goering. I was in a Soviet navy uniform. He couldn't forgive me for taking his picture that way. He started screeching at me, "Russian pig, get out of here." An American MP ran over and asked what was going on. I said, "I just wanted to take his picture, I don't know why he's yelling like that." So he told him to shut up. Goering kept at it, so the American hit him with his stick on the shoulder, and said, "Shut up, you son of a bitch."

Khaldei sometimes ends the story with: "If only he had known I was a Jew!"

POSTWAR Khaldei's stint as court photographer ended abruptly in 1948. There were two likely causes, either of them fully sufficient in Soviet terms. First was the "anti-cosmopolitan" campaign that broke out that year, targeting Jews in the sciences and arts, including journalism. (The anti-Semitic frenzy, culminating in the infamous Doctors' Plot, did not let up until Stalin's death in 1953.) The second cause was Tito. Khaldei had been alone with him in Belgrade, in a picture-taking session in Tito's office—and a lot of people knew it. Then in 1948, Tito broke with Stalin, turning overnight from Soviet friend to public enemy. The result for Khaldei was a series of unpleasant conversations. Ultimately, with no reason given, he was fired from TASS.

At this point, Khaldei had a serious need for a steady income: he had gotten married three years earlier, and now had a family to support. His wife Svetlana had spent the war years in the photography department of SovInformburo. She had a medal for the defense of Moscow. In 1945, both of them were utterly alone. On October 31, they got some wine, salami, and candy, went to the registry, and then celebrated the marriage in Svetlana's room. Soon after they had a daughter, Anna, and a son, Leonid. Svetlana died in 1986. Today in Khaldei's room there hangs a photograph of his wife in her youth, the light shining through her hair.

For the next decade, Khaldei managed to sustain himself by doing darkroom work, taking assignments from secondary magazines, and through the patronage of his

wartime friend, the writer Konstantin Simonov. The independence of the war years had vanished: to take pictures on the street, even a professional needed a permit. When the photographer Robert Capa visited in 1947, Khaldei tried to stay away from him—or more precisely, from the secret police who were trailing Capa—but when Capa found he couldn't leave the country with undeveloped film, Khaldei did his processing. The political and social climate improved under Khrushchev, both for photographers and for Khaldei personally. In 1959 he was hired by *Pravda*, where he remained until 1976, when a new wave of anti-Semitism, this time in connection with the Jewish emigration, forced him out.

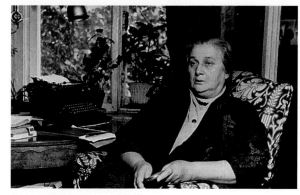

Anna Akhmatova, 1965

Khaldei's postwar photographs constitute an encyclopedia of Soviet life. Some, like *Workers read the newspaper* (page 89) are the overt embodiment of Soviet clichés; others, such as *Iron cots* seem nearly surreal. Khaldei's archive also includes, in great numbers, photographs of artistic spectacles and marching crowds. Life in those years did not lack complexity: it simply was not practice for a photographer to record anything problematic. Khaldei can talk about events that cried out for photojournalism—a cholera epidemic, for example, in the south. But it never occurred to him, nor does it now, that he might have gone there with his camera.

Much different from the postwar marches are Khaldei's portraits of great individuals: Dimitry Shostakovich, Mstislav Rostropovich, Anna Akhmatova. Rostropovich didn't yet have a public face—his picture, taken against a bedsheet, reveals his poverty and his youth (page 90). Akhmatova (above), idolized before the revolution and vilified in 1946, is caught by chance in a friend's room. The tormented Shostakovich sits rigid at the piano (page 91).

Perhaps because of the problems of postwar life, war remained for Khaldei an emotional touchstone. He sought veterans whose pictures he had taken, visited with them, and took their pictures again. And sometimes they sought him. One who did so was Marshal Georgy Konstantinovich Zhukov, supreme commander of the Soviet forces. Forcibly retired, Zhukov invited Khaldei to his *dacha*; he wanted a blowup of Khaldei's photograph of him on the white horse. Khaldei brought it to Zhukov, and while he was there, took his photograph (page 94). This would be Zhukov's final portrait.

Fifty years after the end of the war, Khaldei returned to the world scene. He was invited back to Berlin, this time for an exhibition, and received a medal from the French Ministry of Culture. His wartime photographs were reprinted in the anniversary issues of magazines throughout Europe; the *New York Times* twice featured his work. In 1995 he had his first American exhibition, at the Picker Gallery of Colgate University. Two major exhibitions followed, the first at the Jewish Museum in New York, the second—a large retrospective—at the Jewish Museum of San Francisco. Amidst the flood of openings and accolades, Khaldei became, at age eighty, a frequent traveler.

One of the places he traveled to was Hamilton, New York. Over many conversations, both here at Colgate and in Moscow, Yevgeny Ananievich Khaldei has captivated us with his wit and compassion. We are honored to have known him, a great photographer, and a splendid storyteller, the embodiment of the Russian phrase "a man of rare soul."

—A.D. and A.S. Nakhimovsky

13

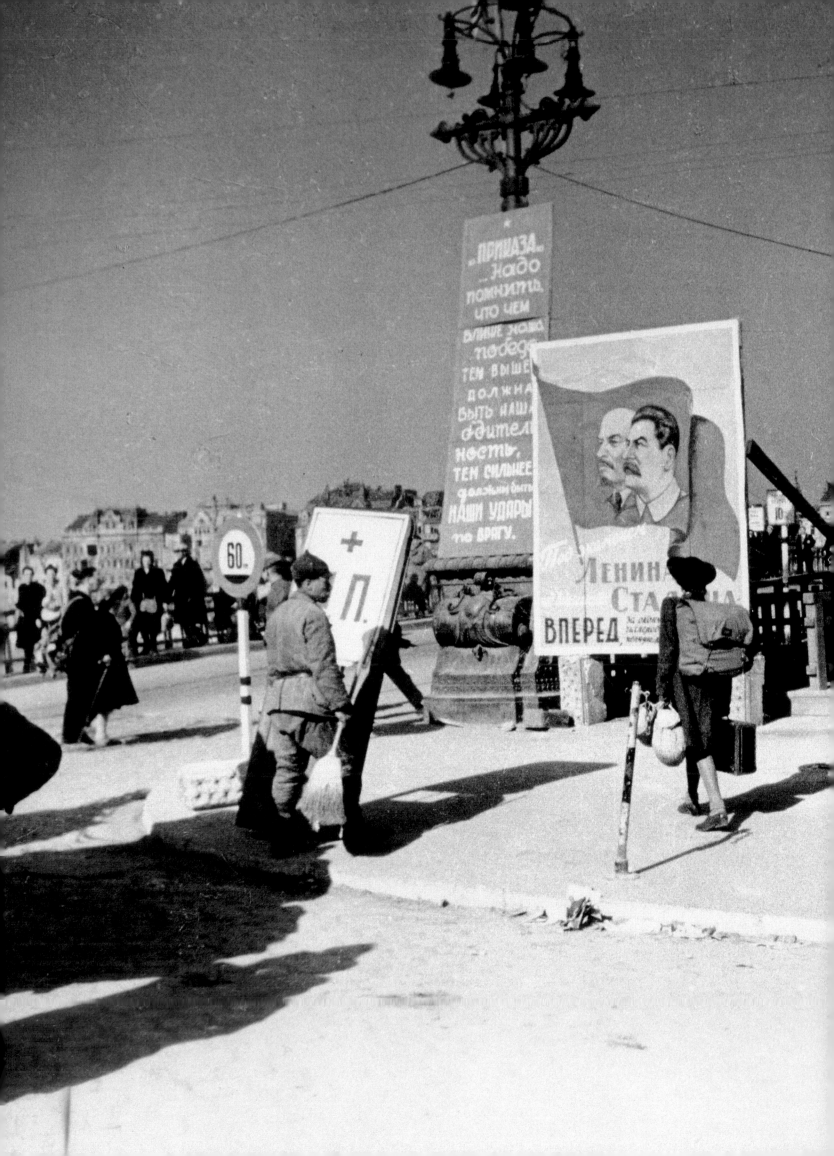

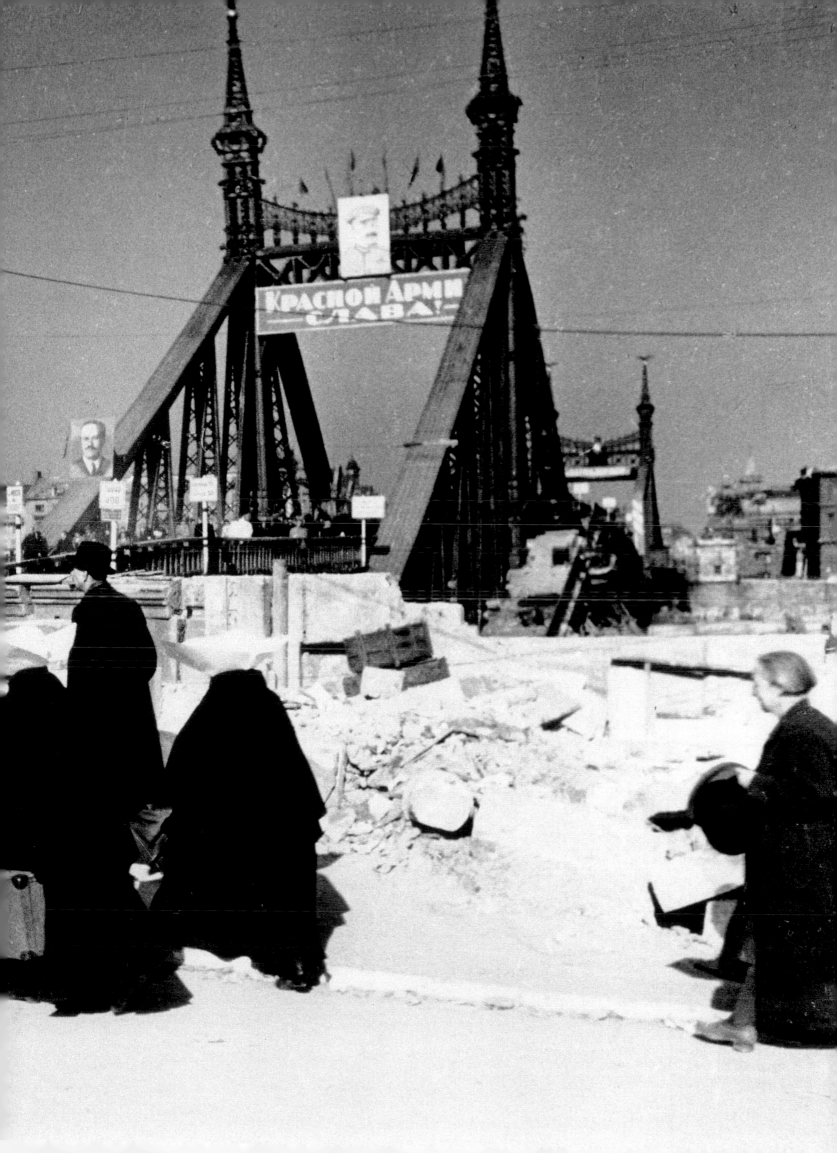

WAR BEGINS

Up to the start of the war, there was an eerie tranquillity. The day before the Nazis invaded, Khaldei was in Tarkhany, a town in central Russia that was the birthplace of the poet Mikhail Lermontov. June 21 was the hundredth anniversary of the poet's death, and Khaldei was photographing children reciting his verse.

The Nazi invasion began at four A.M. the next morning. By the start of the day, it was obvious that something big had happened. An important radio announcement was scheduled for 12:00 noon. Neither Khaldei nor any of his friends would speak their suspicions out loud, not only because the prospect of war was so dreadful, but because they were afraid to utter the truth before it had been officially sanctioned.

The TASS building, where Khaldei worked, had loudspeakers on the roof. He saw people gathering to hear the announcement and went outside with his camera. He took just one photograph. It would be the first photograph he took of people as they really were: not heroes of labor, just ordinary men and women who suddenly had a war to contend with.

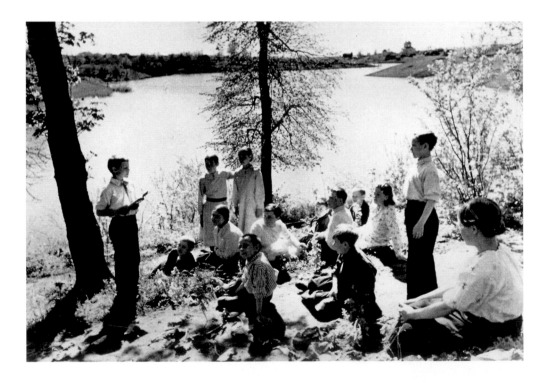

Pages 14–15: "Forward under the banner of Lenin and Marshal Stalin," Budapest, 1945. *Above*: Tarkhany, June 21, 1941. *Opposite*: Moscow, June 22, 1941. *Pages: 18–19*: Reconnaissance mission, Murmansk, 1941. *Pages 20–21*: Reindeer, Murmansk, 1941.

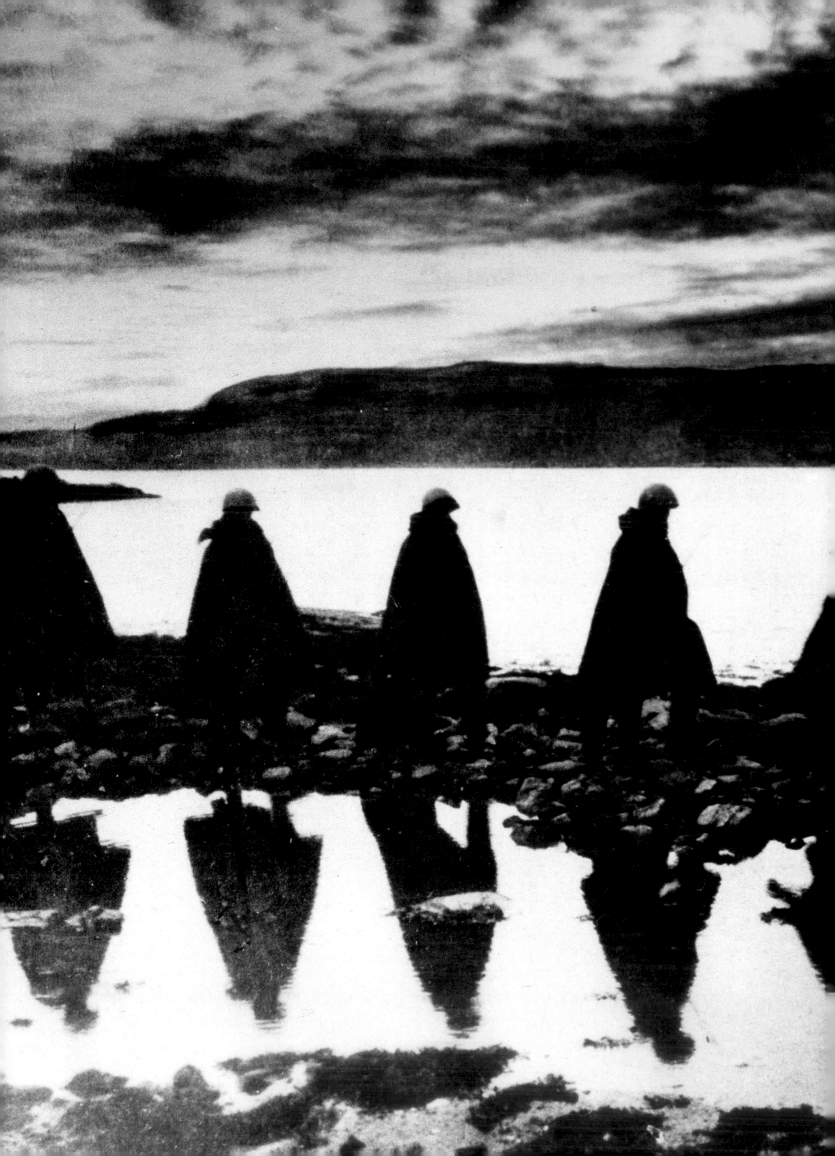

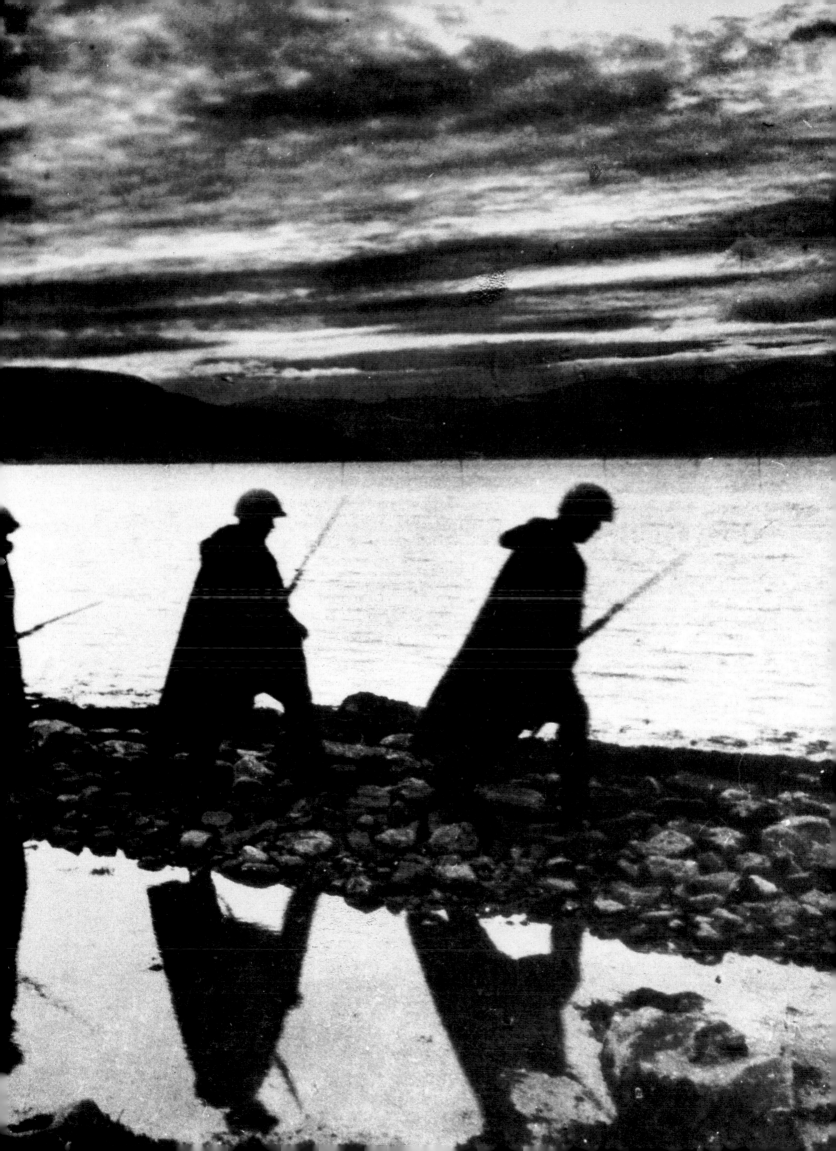

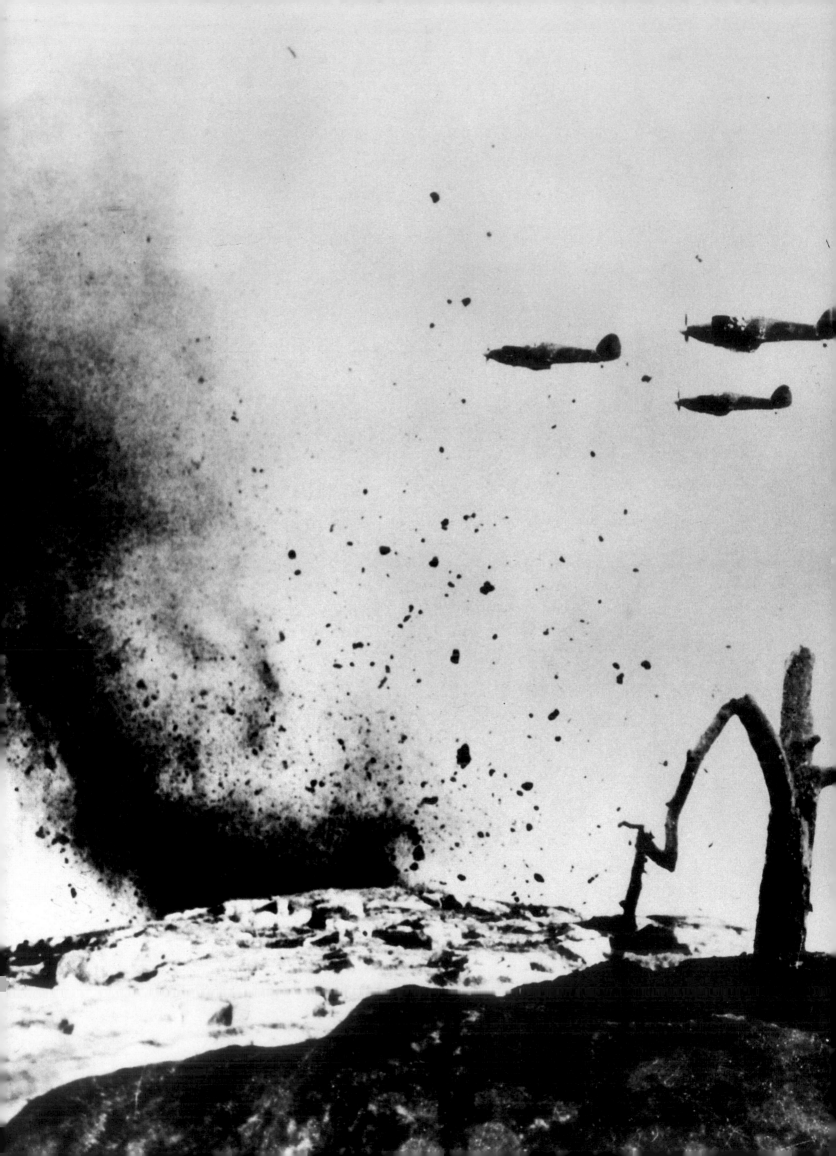

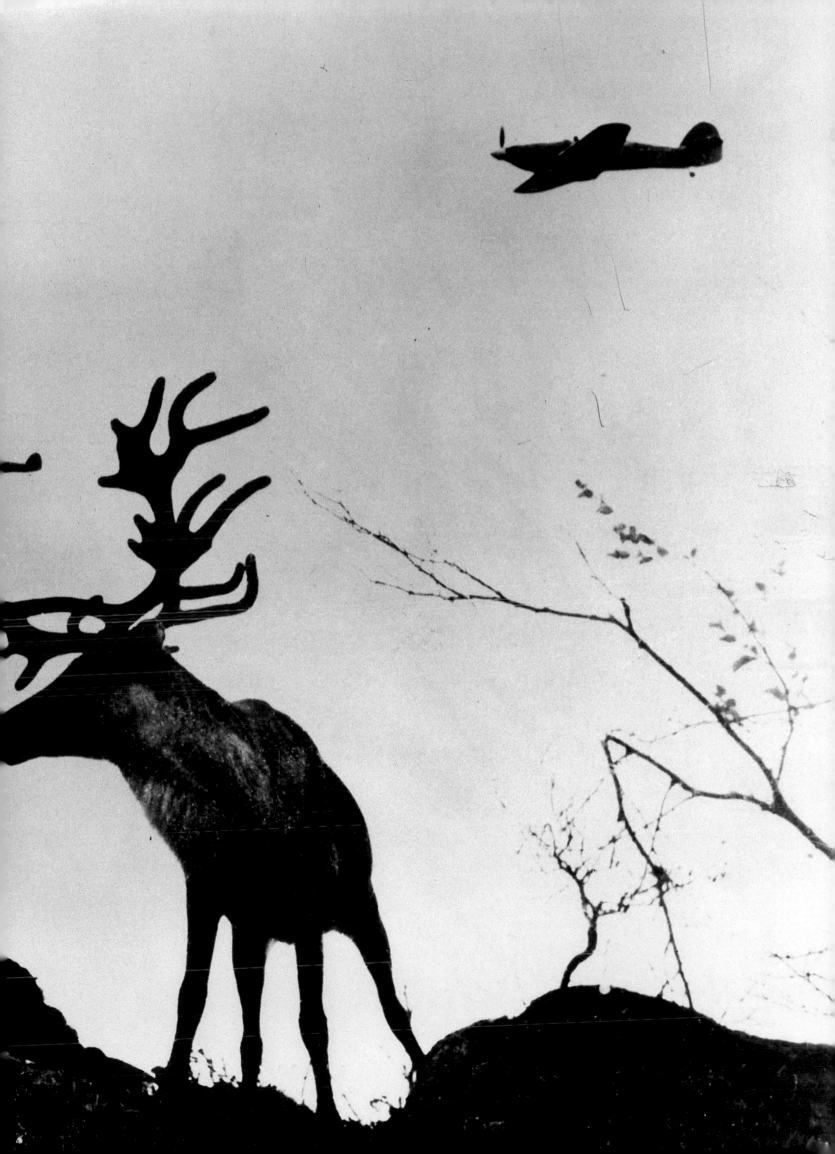

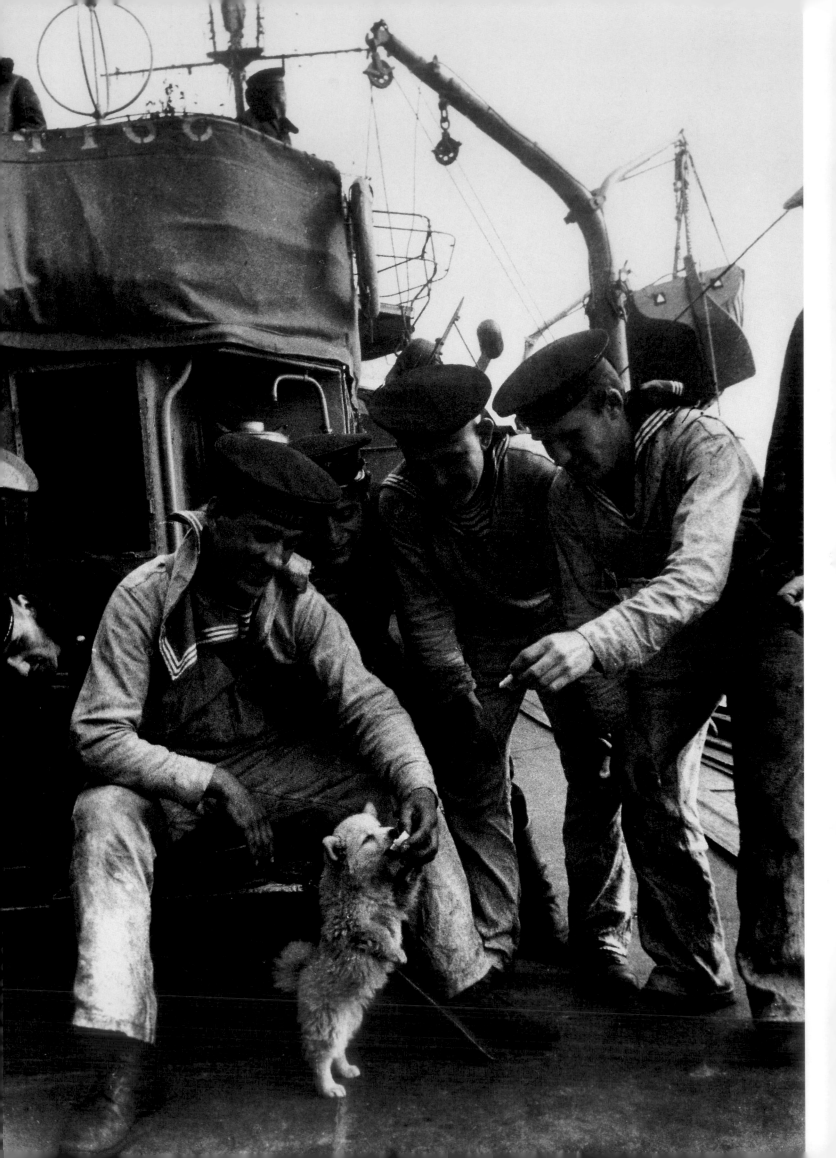

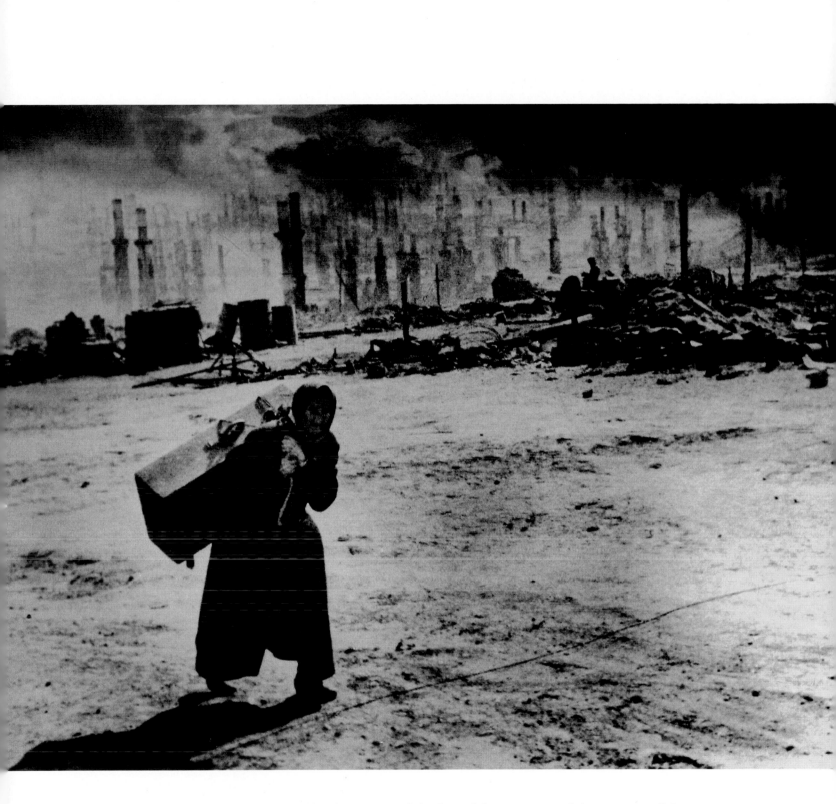

An old woman was walking all alone, and behind her were chimneys, chimneys, chimneys—all that was left of wooden Murmansk. I had my Leica around my neck, and I took a picture of her walking with her box. Suddenly she stopped and said, "Aren't you ashamed of yourself, taking pictures of our suffering?" I didn't expect a question like that, so specific, from such a simple old woman. My God. So I said, "What can you do, mother? It's everybody's suffering."

Opposite: Sailors' leisure, Murmansk, 1941. Above: Old woman, Murmansk, 1941. Pages 24–25: Murmansk, 1942.

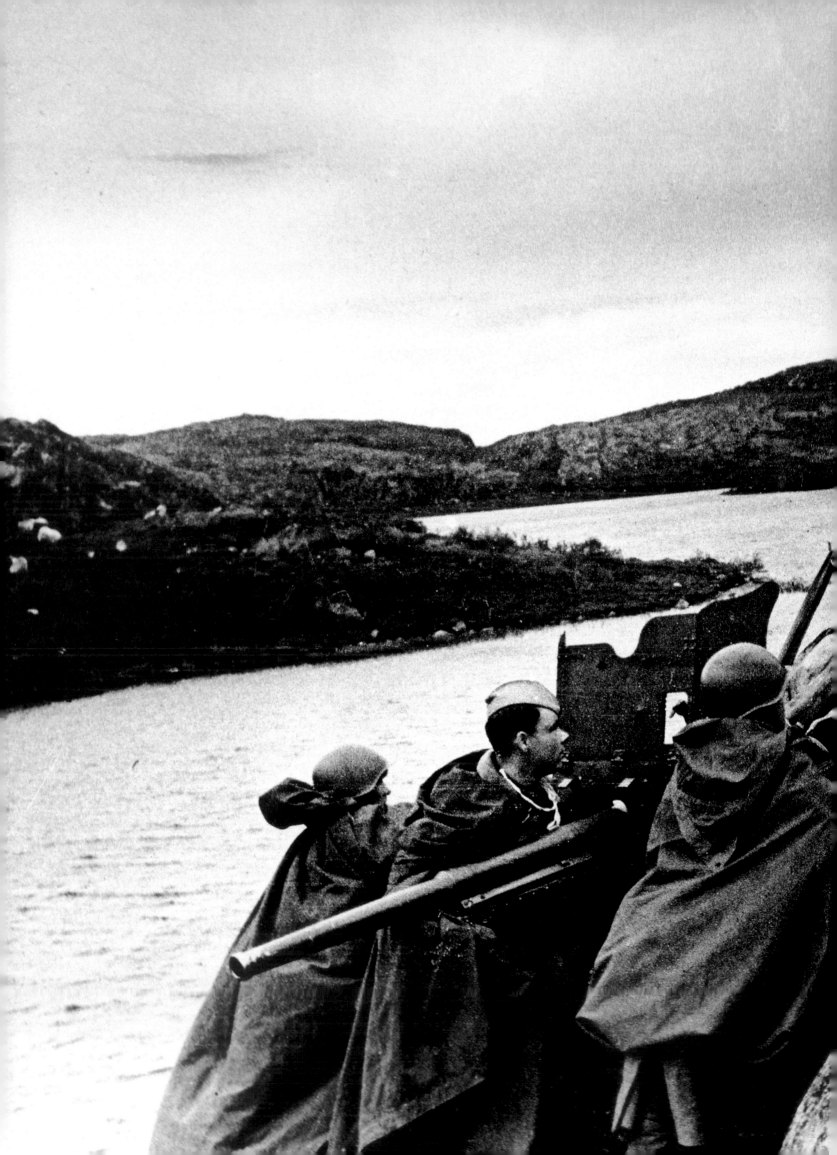

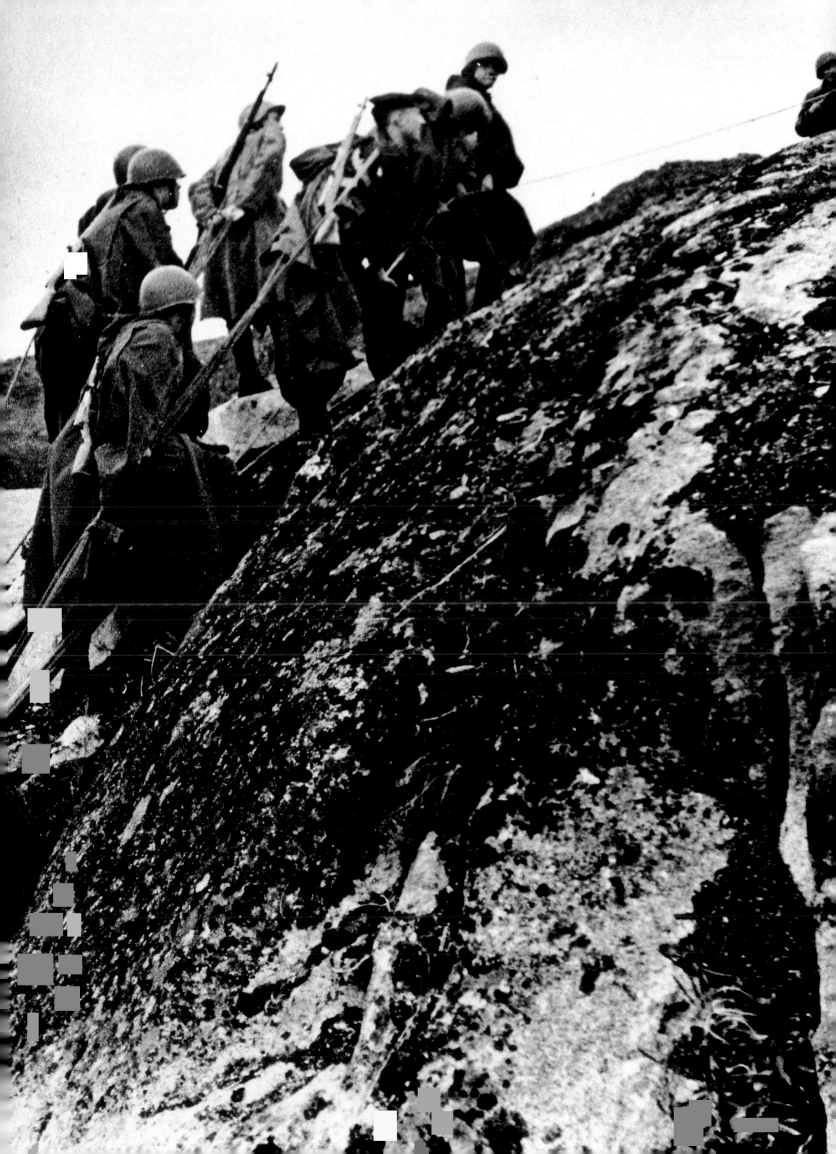

THE WAR IN THE SOUTH

In the summer of 1942, the Red Army lost the Crimea and part of the coast to its east. The situation improved somewhat in February, 1943, when they established a beachhead just south of Novorossiisk; they held onto it for six months, until the whole area was liberated. Many of the photographs that follow were taken from that beachhead. Khaldei explains how he got there:

I had a friend, a journalist. He said, "Do you want to go to the beachhead, there's a boat leaving tonight." My colleagues were against it—they said, "You aren't going to get any pictures there." I said, "I'm going." So we set off, not through the bay, the bay was under constant shelling, but around it. The Germans were holding the height and they could see everything. There was a cliff,

the boat couldn't get up to the shore. The commander gave a shout, "Out of the boat, into the water, up the cliff!" You couldn't lag behind because the area was being shelled. I climbed as fast as I could. There were trenches already dug there to hide in. So I hid. The shelling slowed down and toward day-break it stopped. There was some kind of agreement between

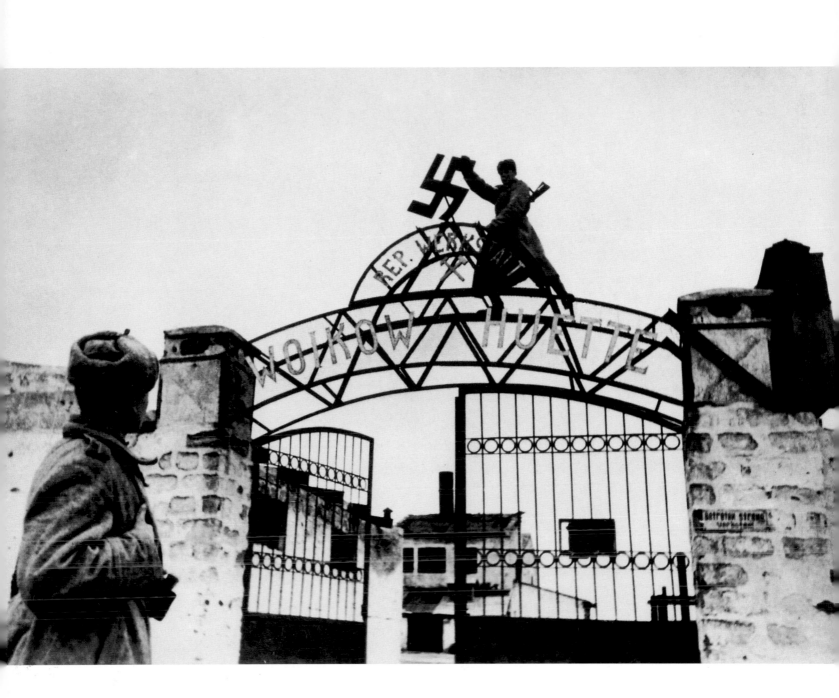

the Germans and us to give the soldiers some rest. In the morning it was so quiet I thought, "God, what's going on here?" I took a walk and saw a girl washing sailors' undershirts. That's when I took the shot of the sewing machine and the soldier getting a shave.

Opposite: Liza the sniper, Novorossiisk, 1943. *Above*: Tearing down the swastika, Kerch, 1943. *Pages 28–29*: Women pilots ("night witches"), Novorossiisk, 1943. *Pages 30–31*: Sky over Sevastopol, May, 1944. *Pages 32–33*: Executed Russian POWs, Rostov prison, 1943. *Pages 34–35*: Outskirts of Sevastopol, 1944. *Pages 36–37*: Novorossiisk, 1943. *Pages 38–39*: Life again, Sevastopol, May 1944.

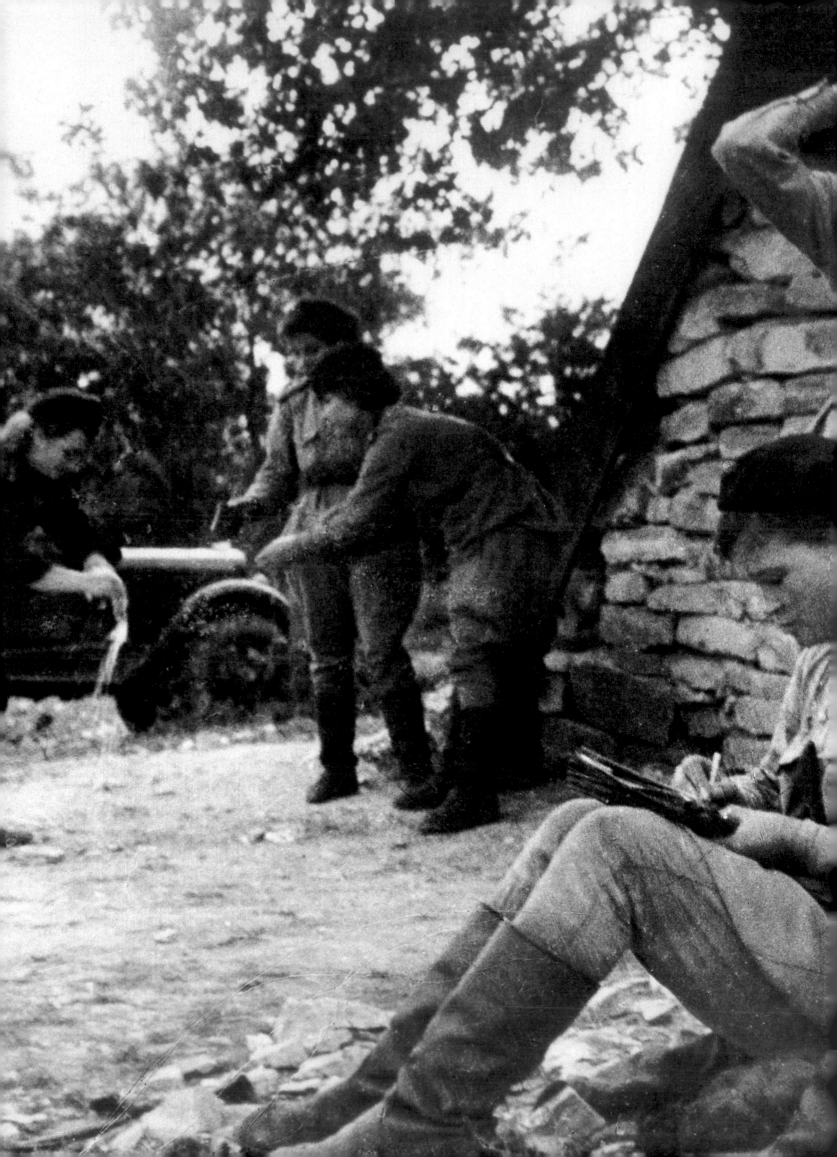

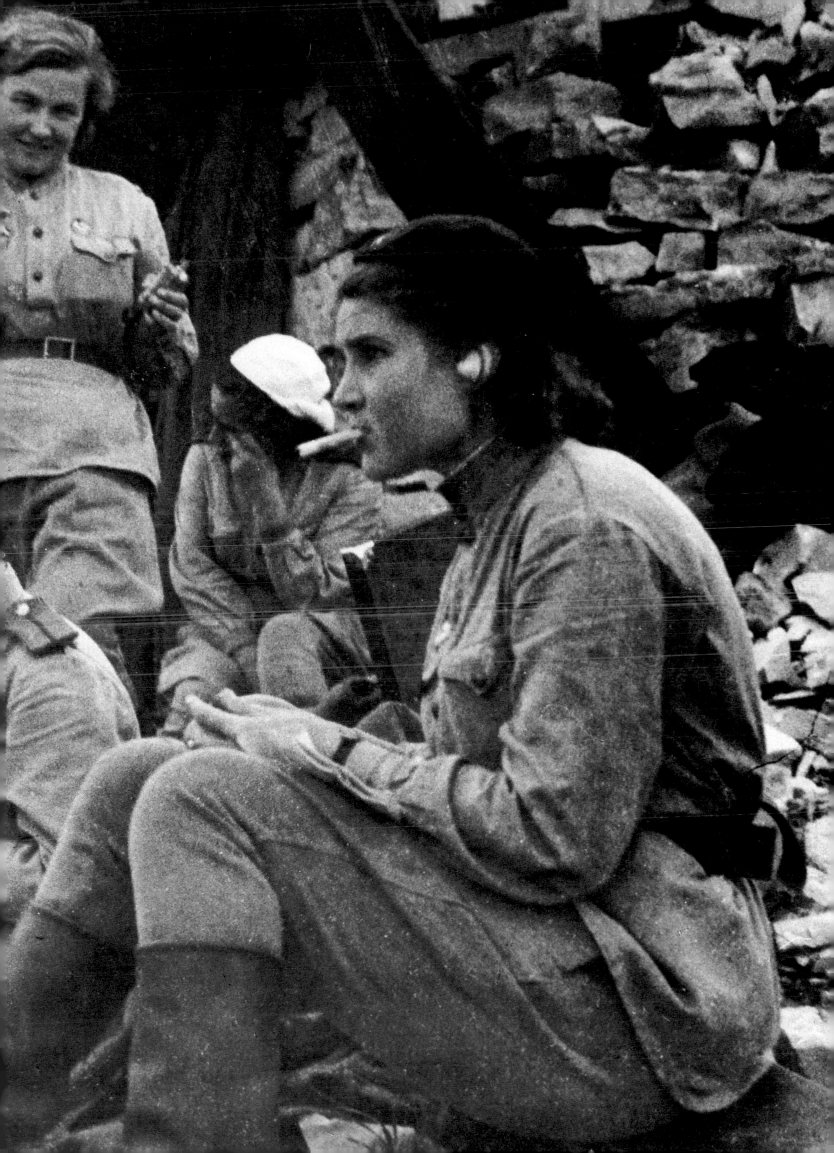

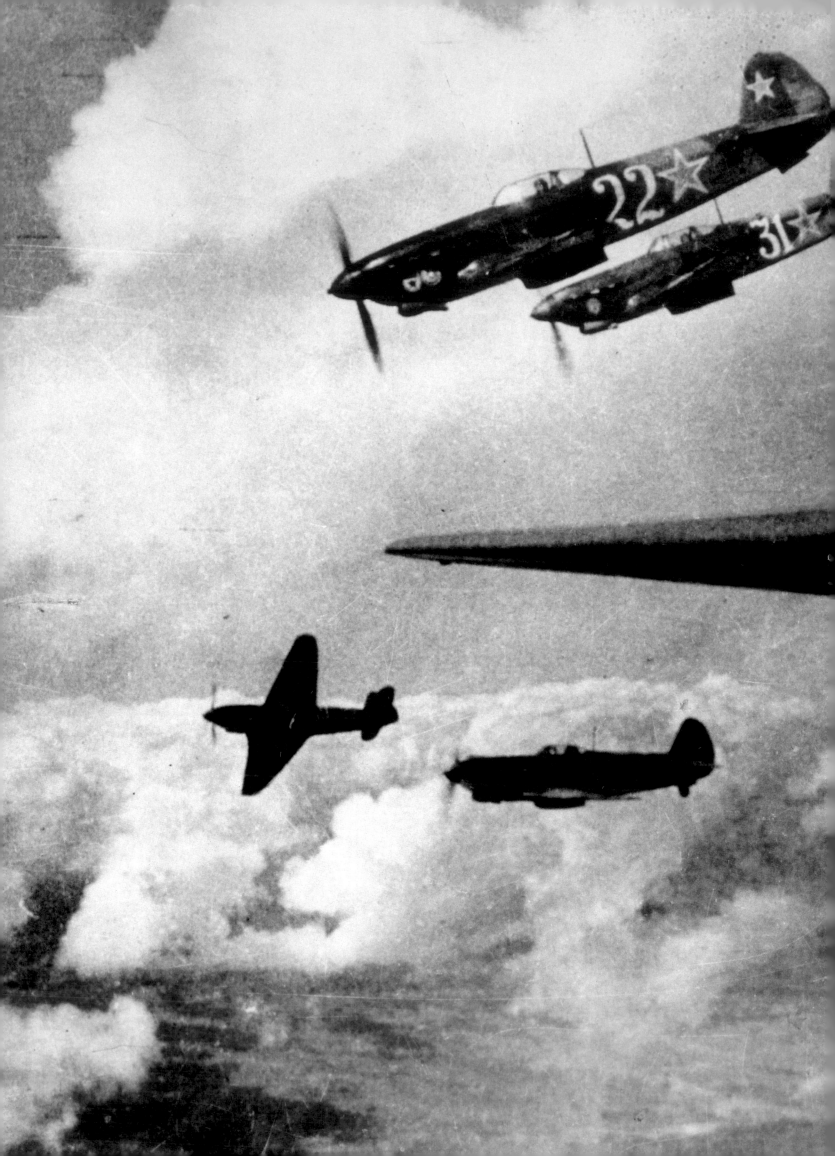

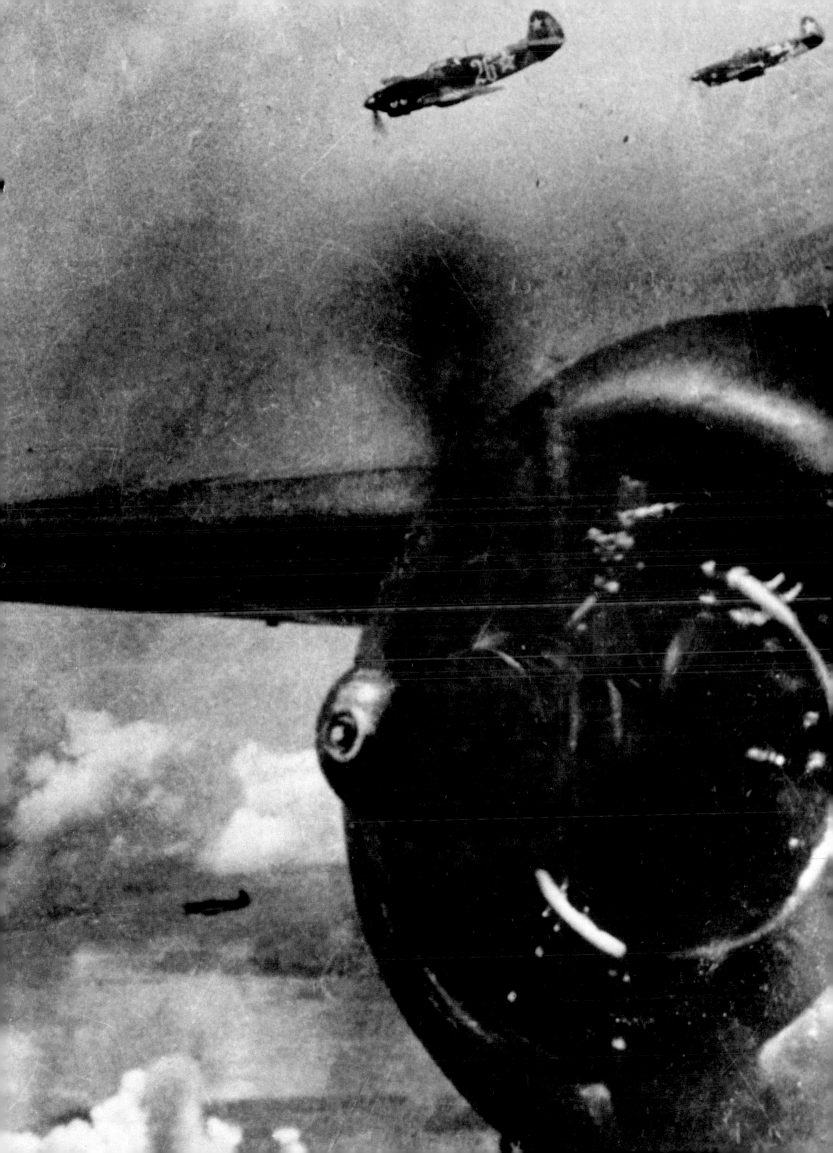

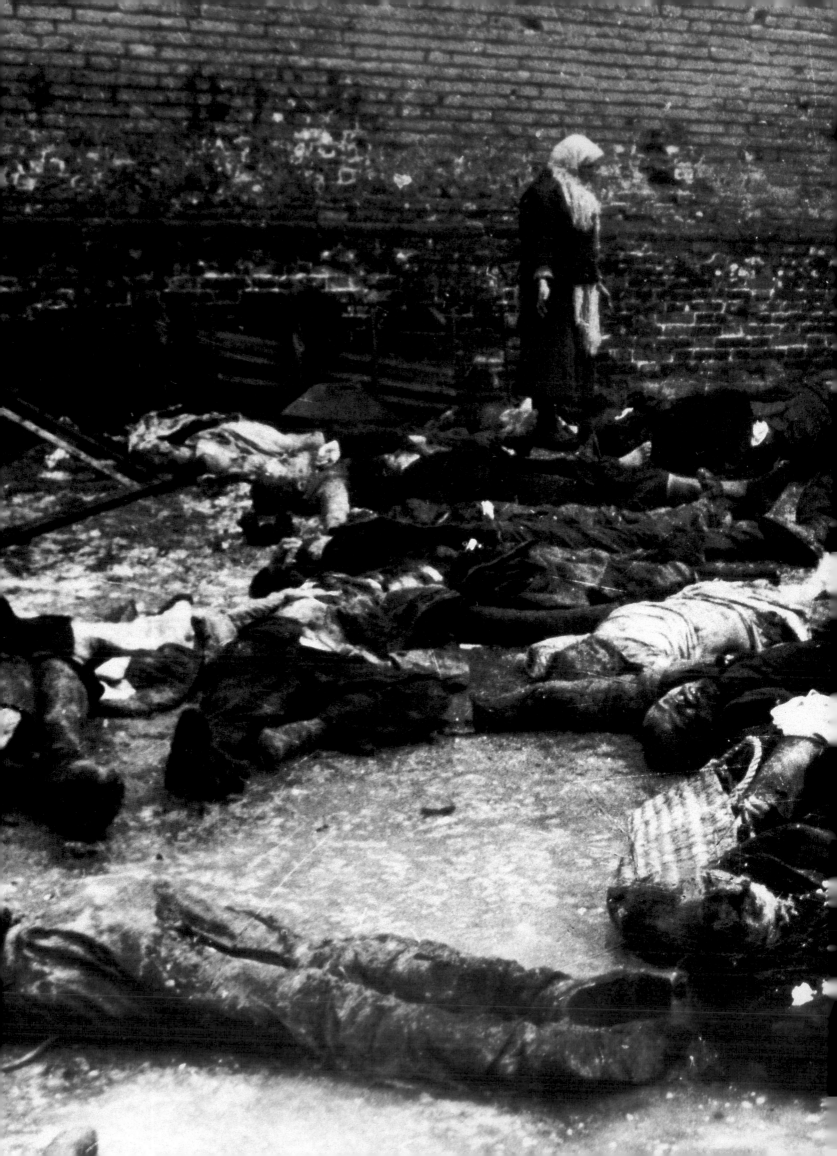

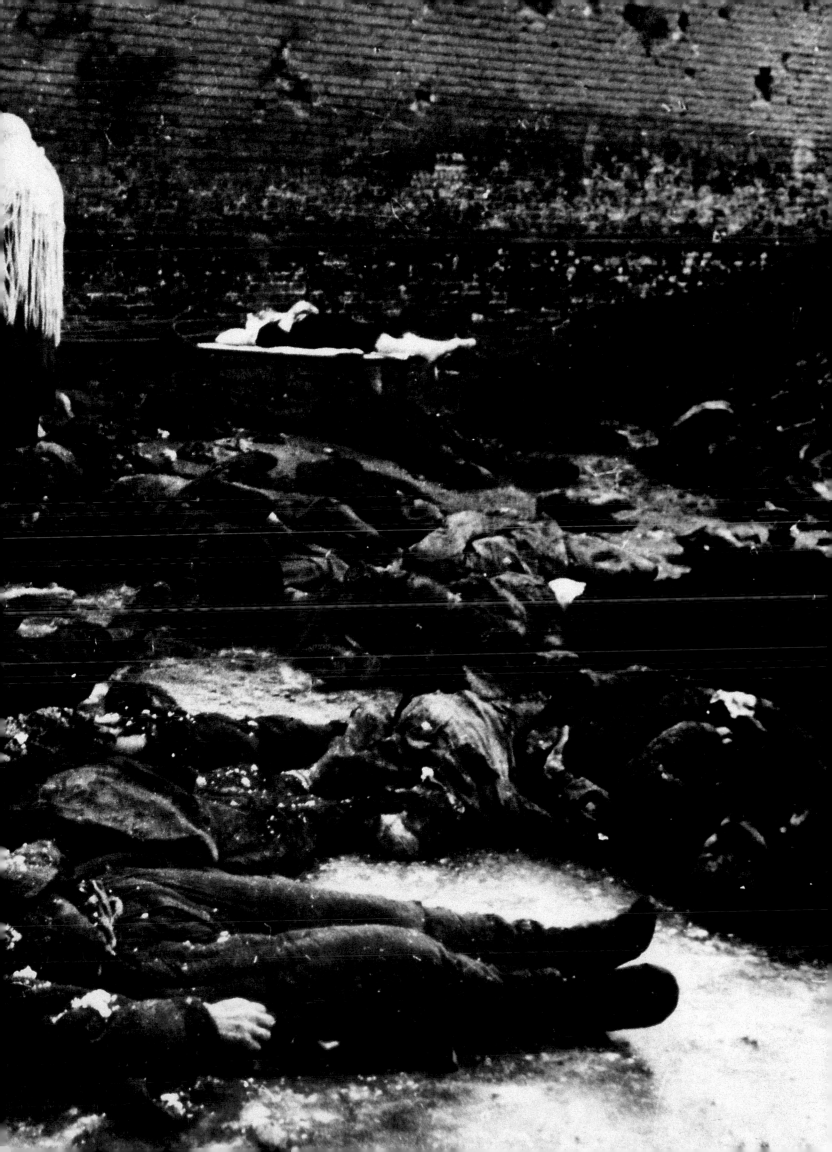

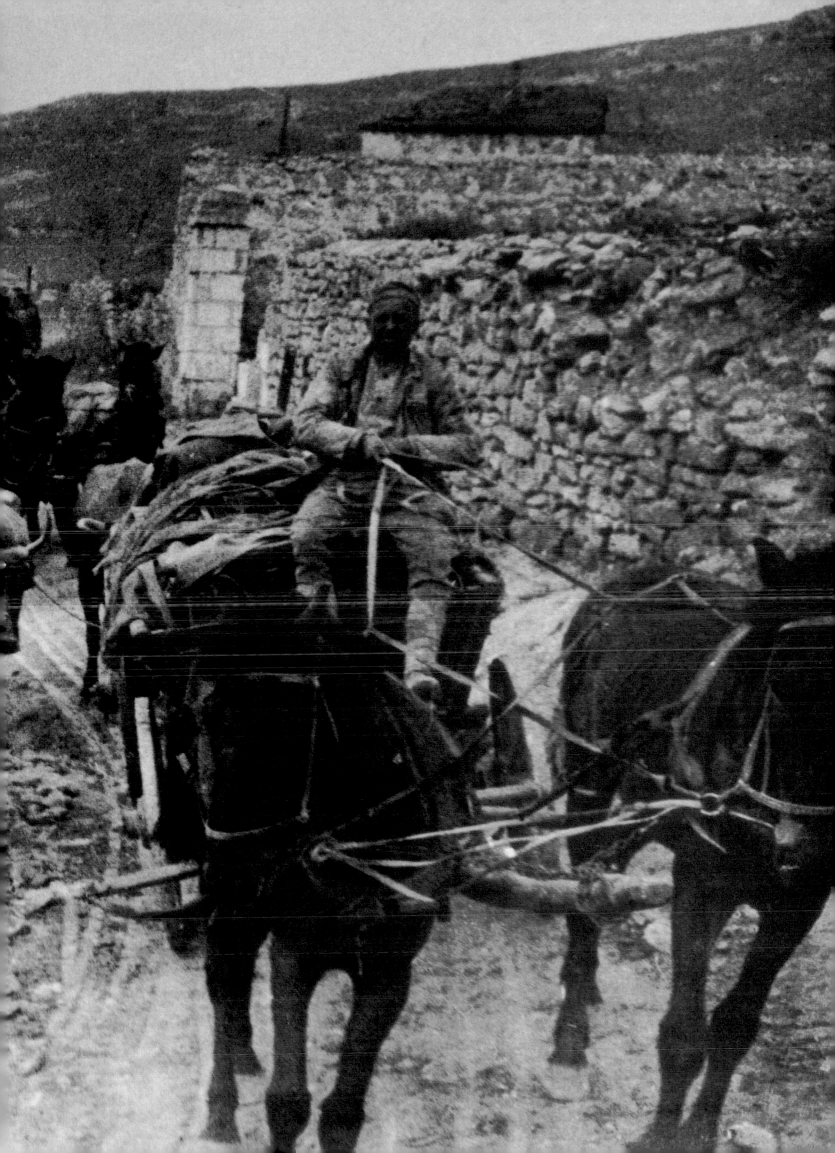

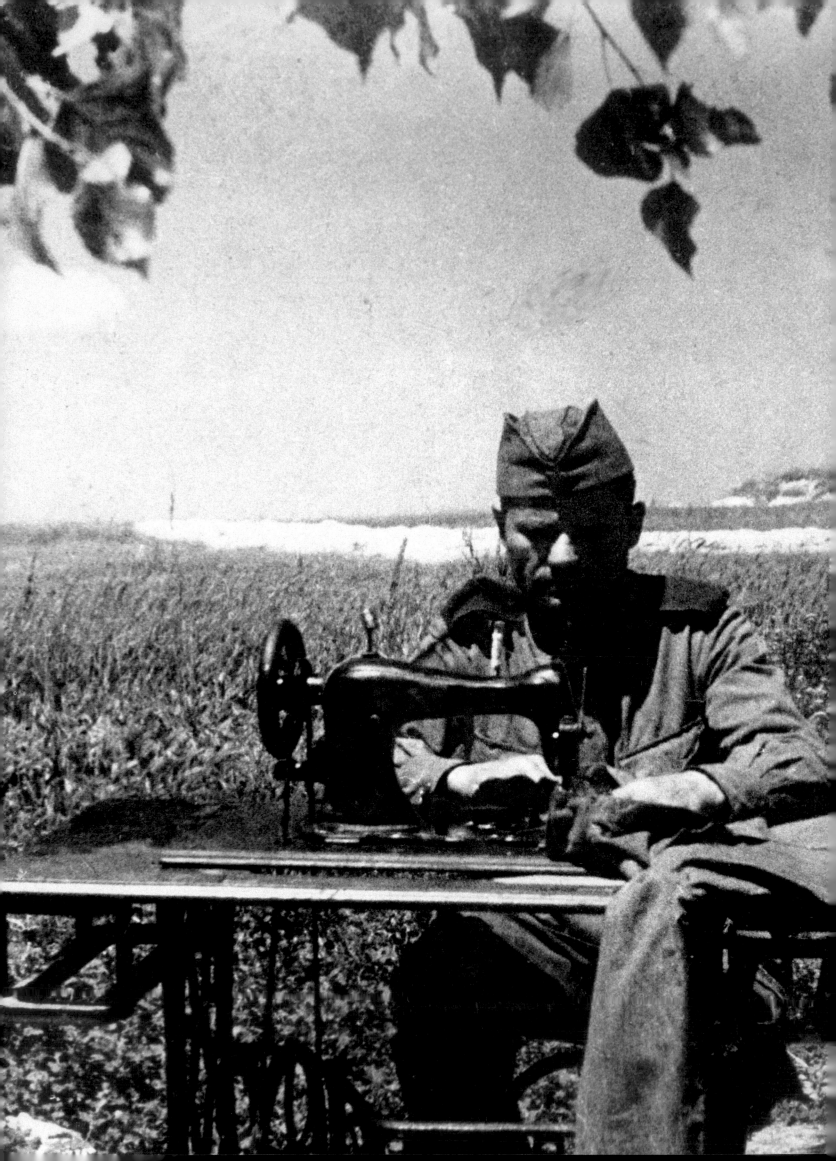

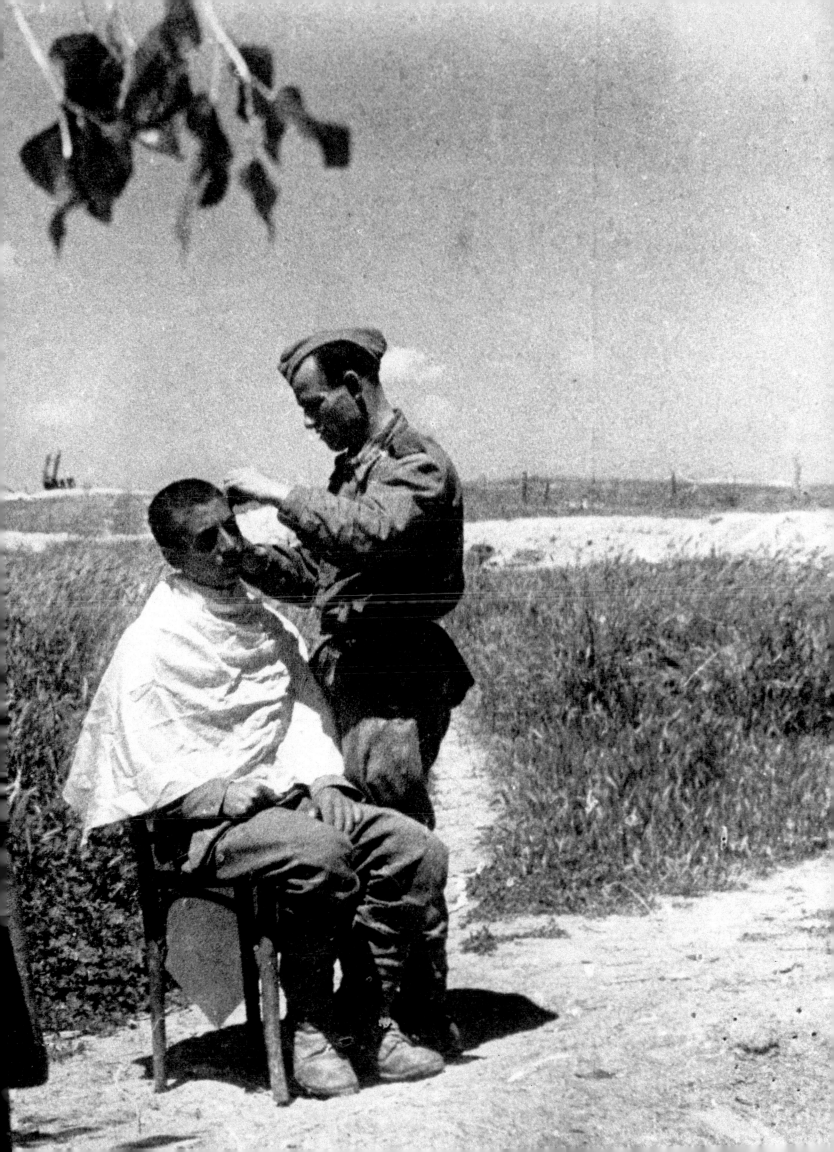

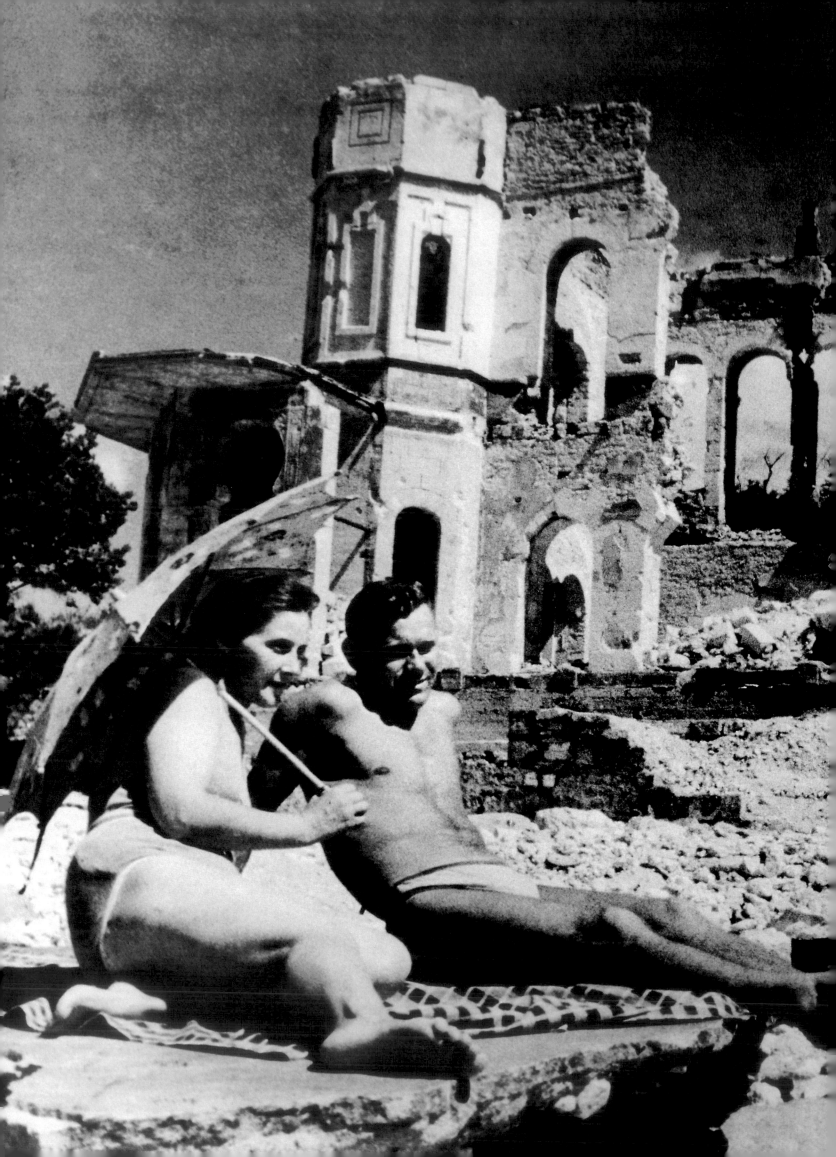

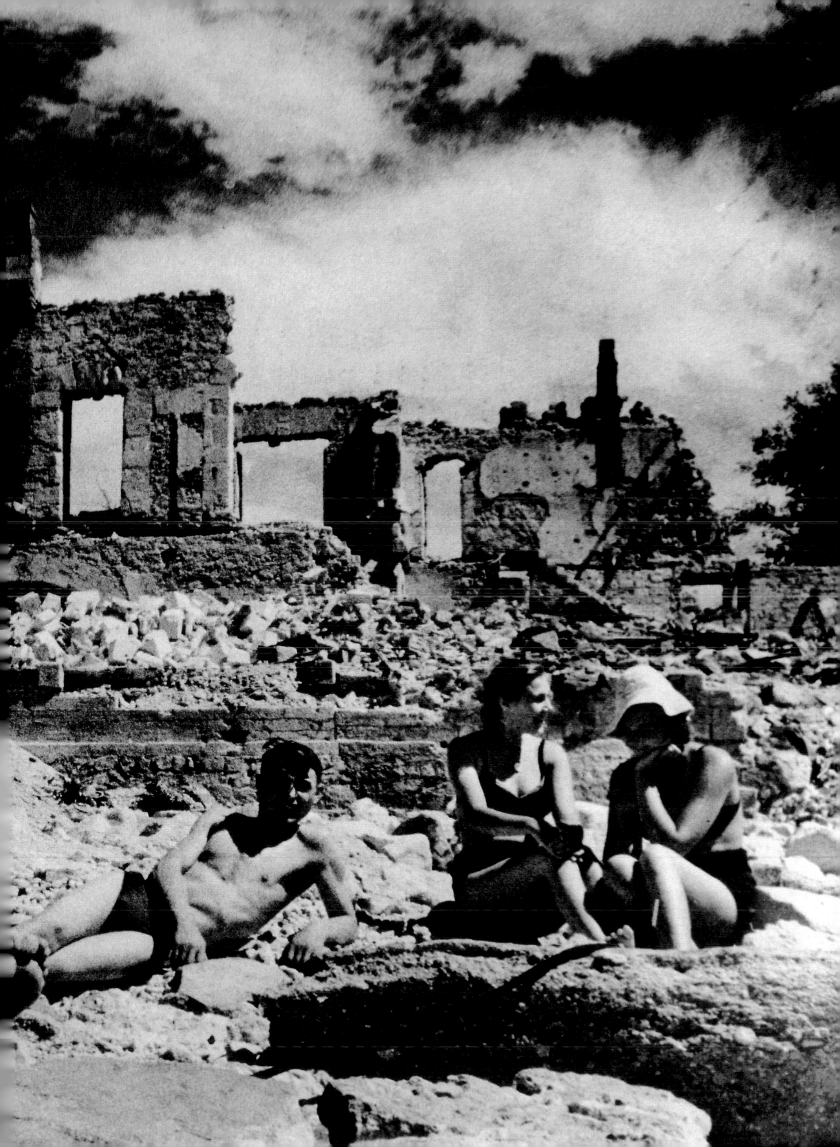

INTO EUROPE

Khaldei followed the Red Army into Bucharest, Belgrade, Budapest, and finally Vienna. In the image of soldiers stepping on a Nazi flag (opposite top), we can see the photographer's sly revenge. The event both was and was not staged:

People often ask me if I put the flag there. I did not. What I did do was set fire to the building. The house belonged to the commandant of a concentration camp. I said to the soldiers, "Let's smash it up." And that's how we defeated the house.

There were also emotions of a different kind. During the liberation of Budapest, Khaldei, whose entire family had perished in the Holocaust, encountered a Jewish couple. He spoke to them in Yiddish and tore off their yellow stars.

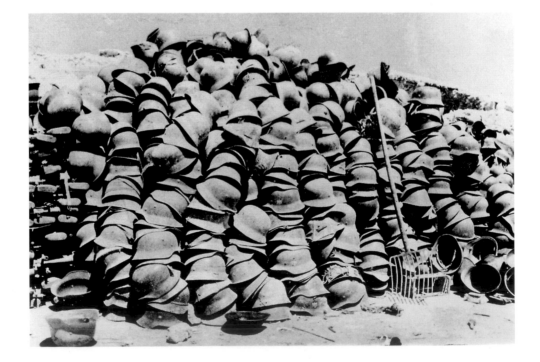

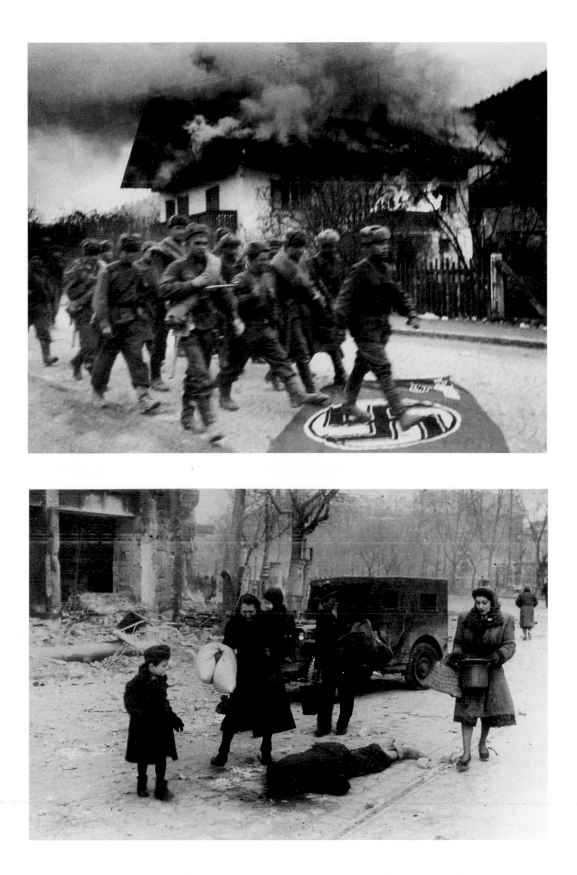

Opposite: German helmets, Sevastopol, May 1944. *Above top*: Outskirts of Vienna, 1945. *Above bottom*: Budapest, January 1945. *Pages 42–43*: Russian general salutes, Belgrade, 1945. *Pages 44–45*: Victory celebration, Lovech, Bulgaria, 1945. *Pages: 46–47*: Budapest, 1945. *Pages 48–49*: Jewish couple, Budapest, 1945. *Page 50*: Murdered Jews in a synagogue, Budapest, 1945. *Page 51*: Budapest, 1945. *Pages 52–53*: Vienna, April 1945.

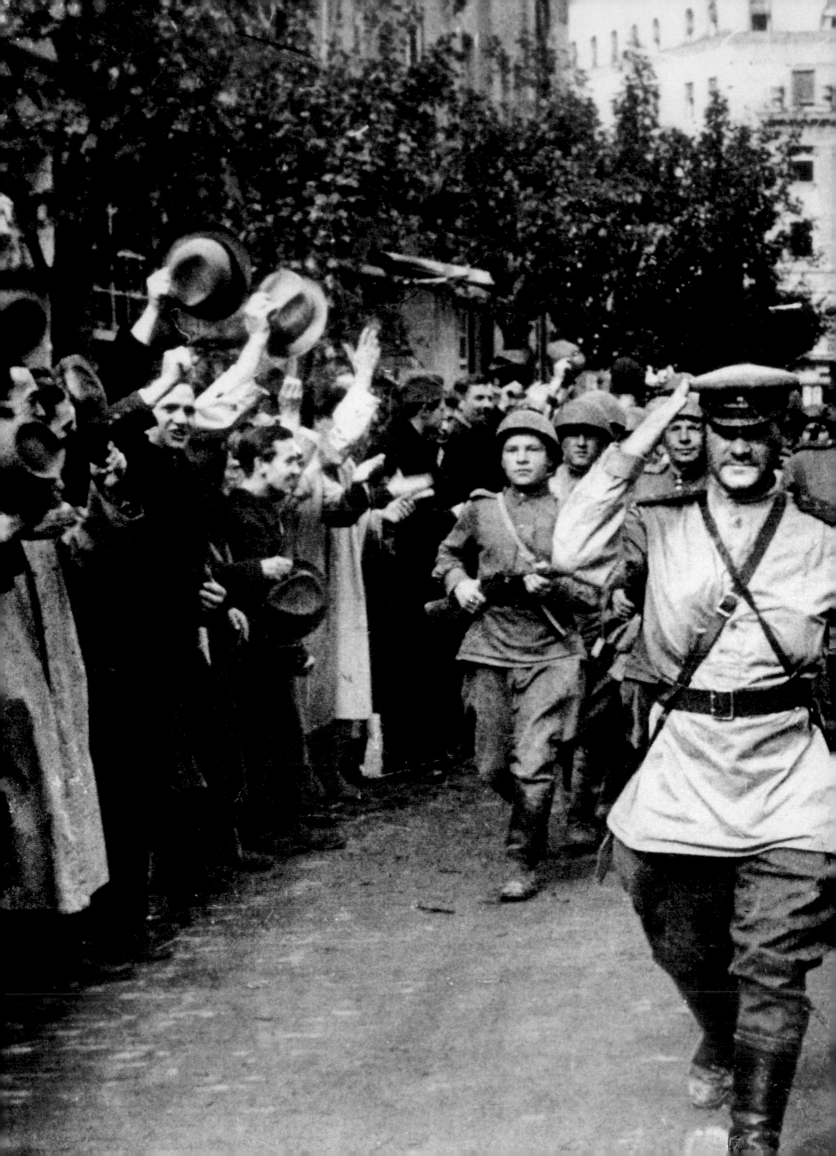

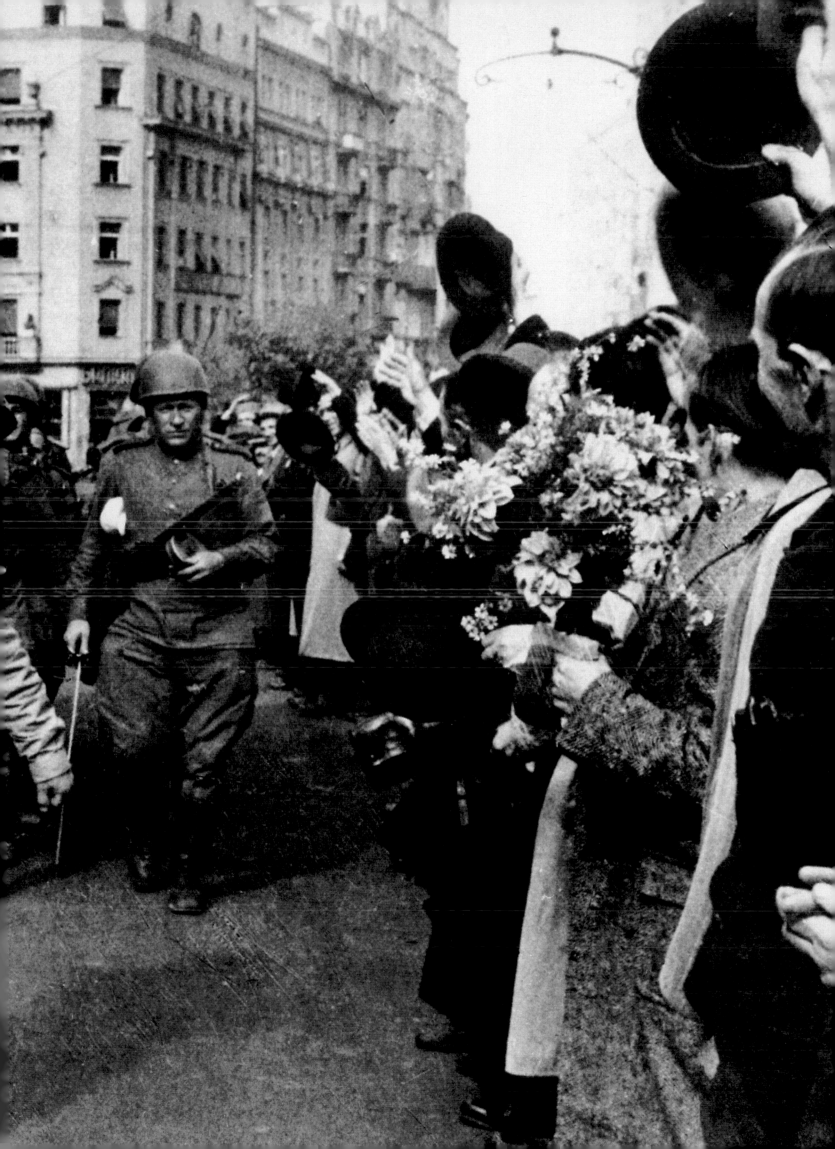

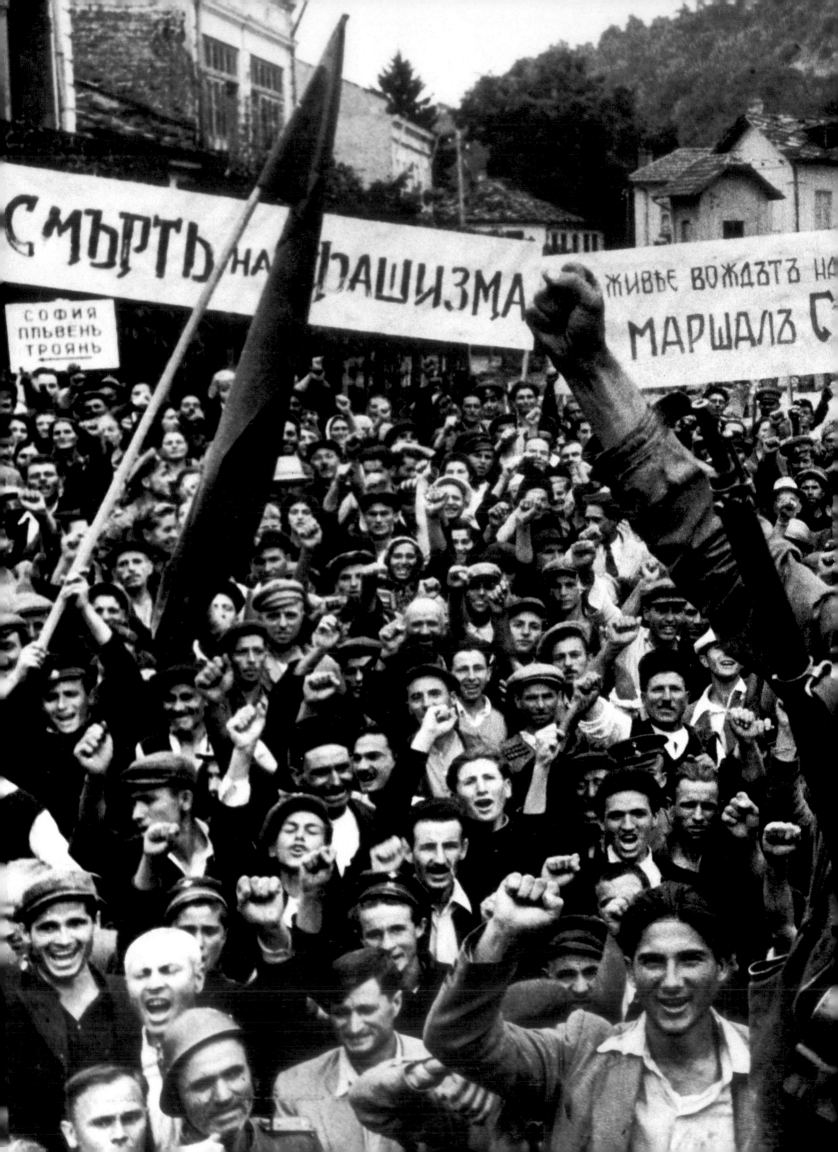

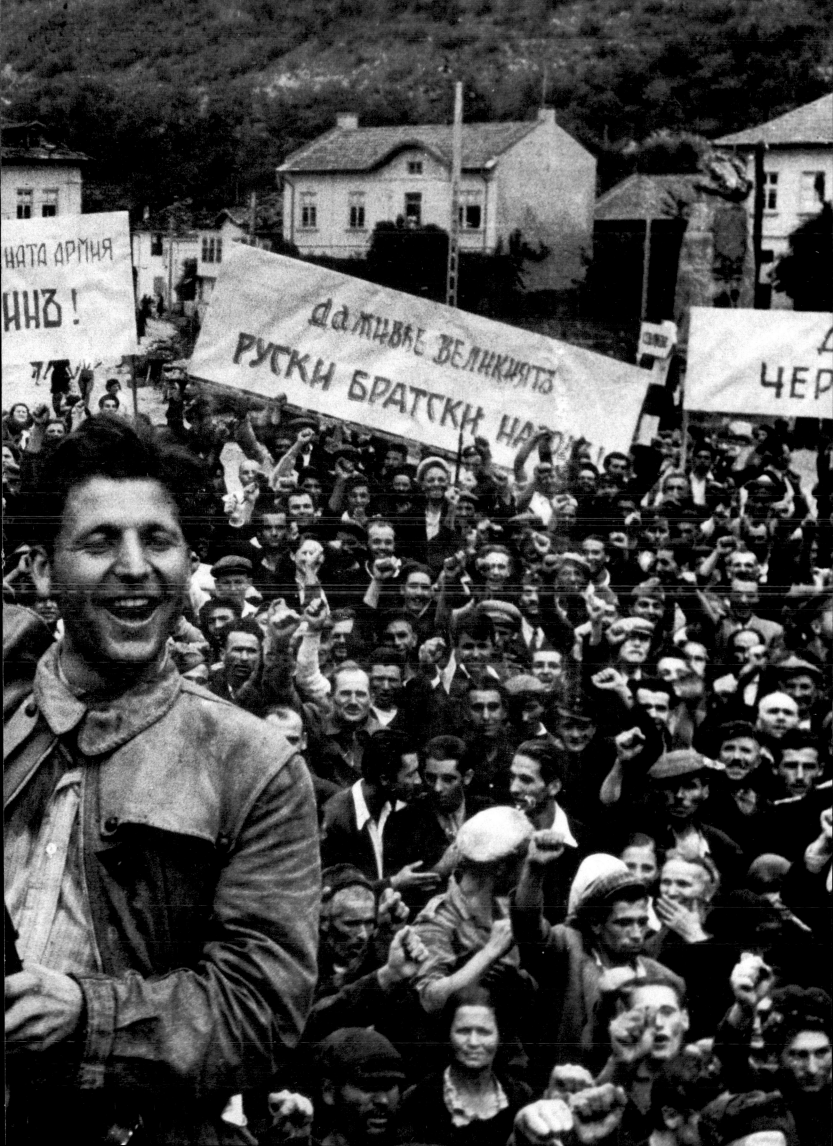

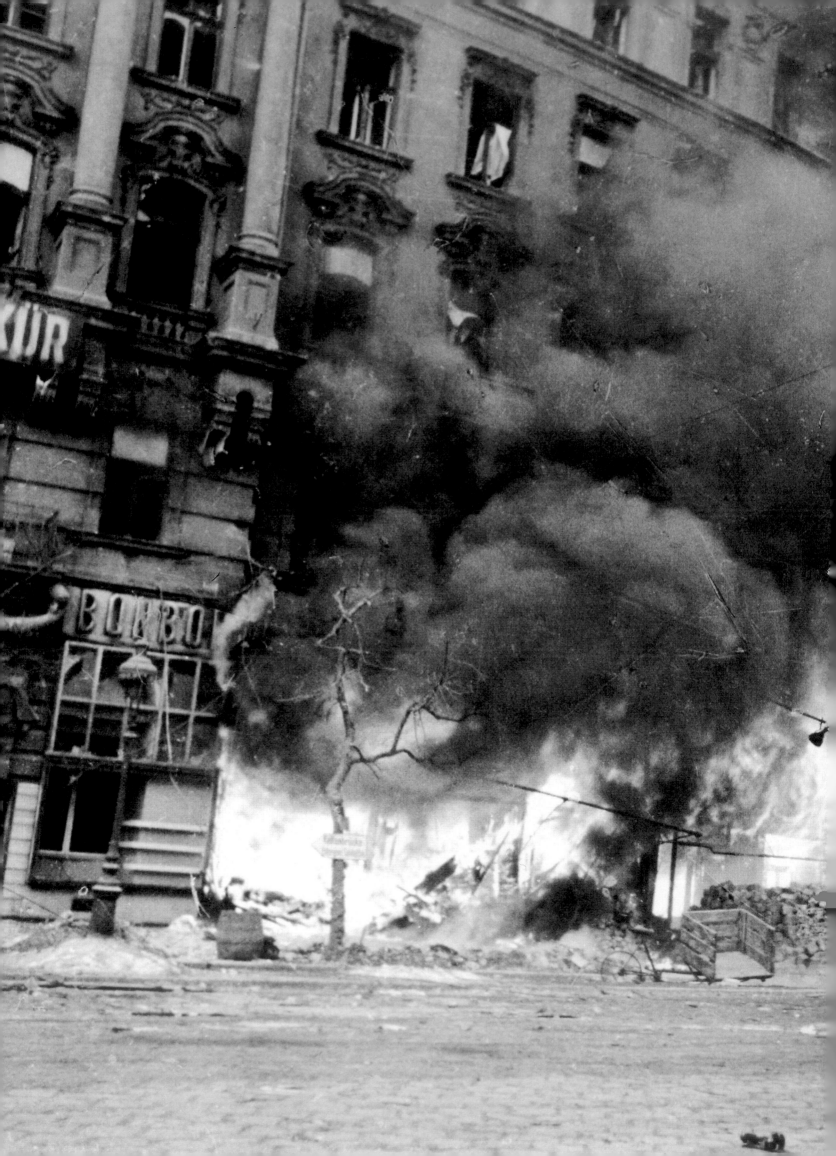

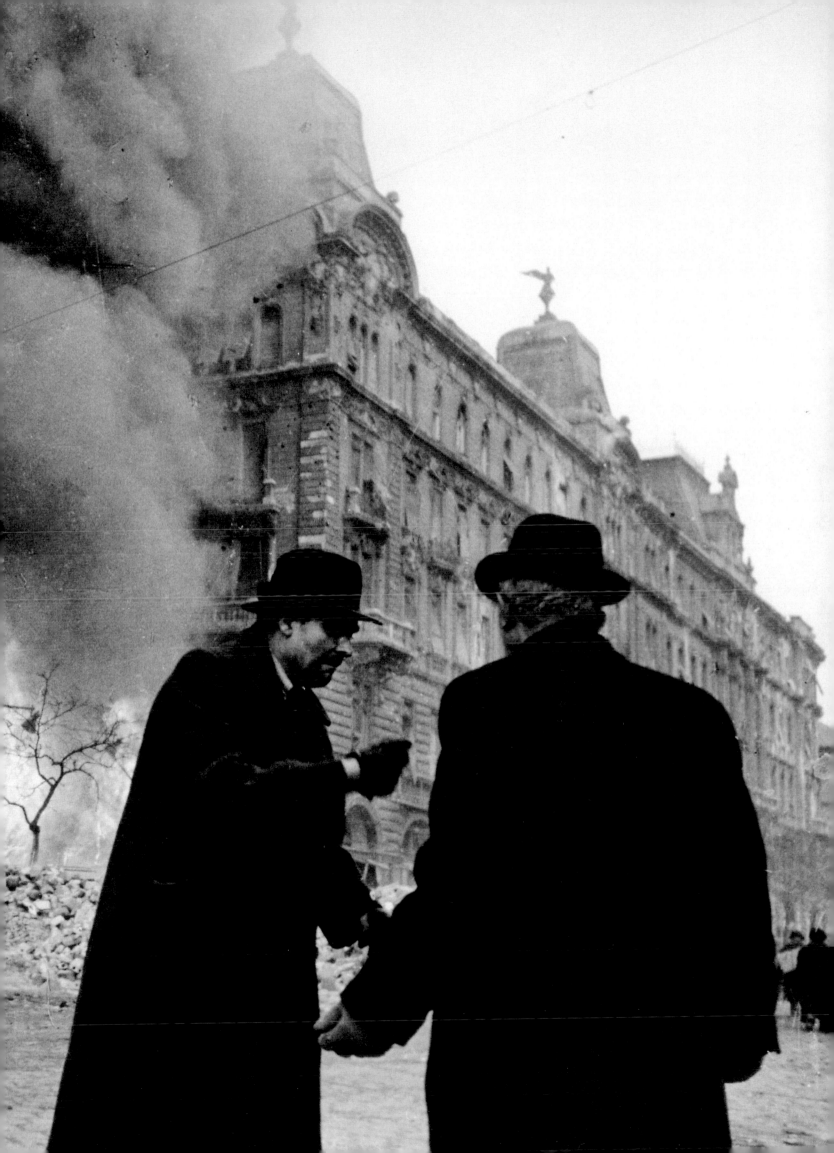

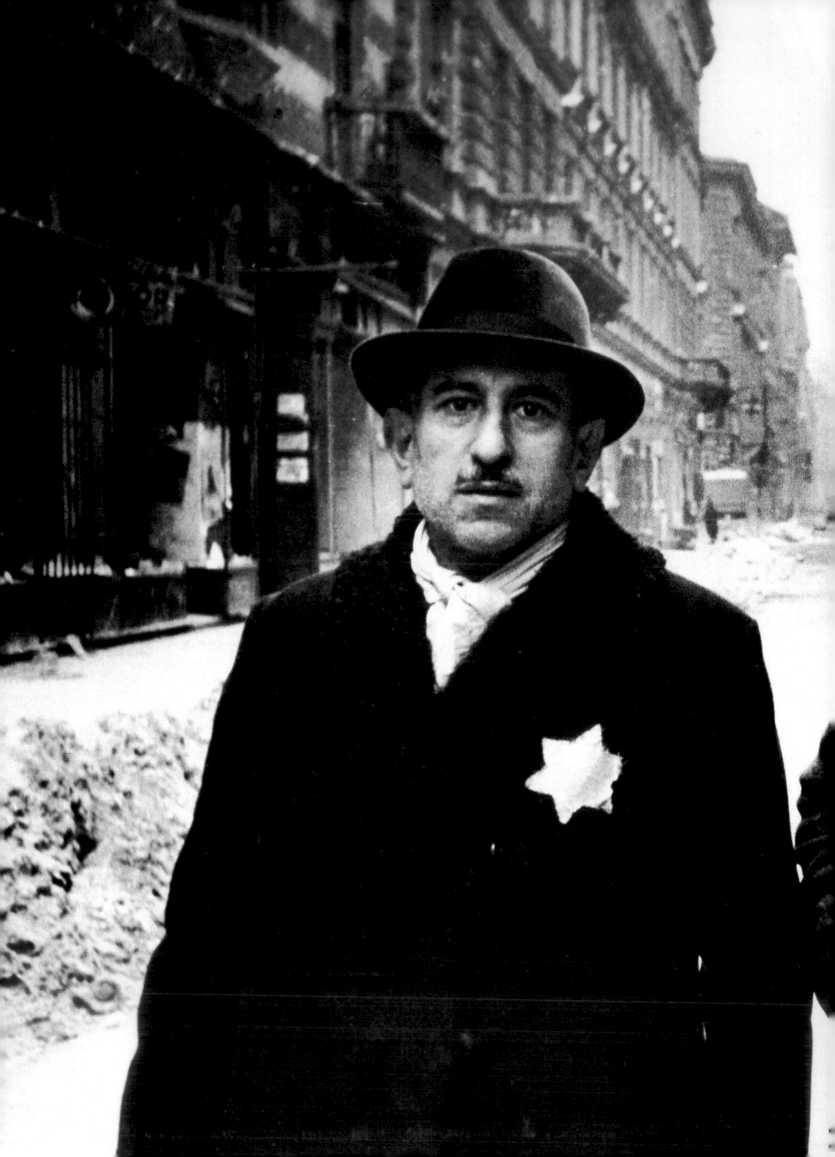

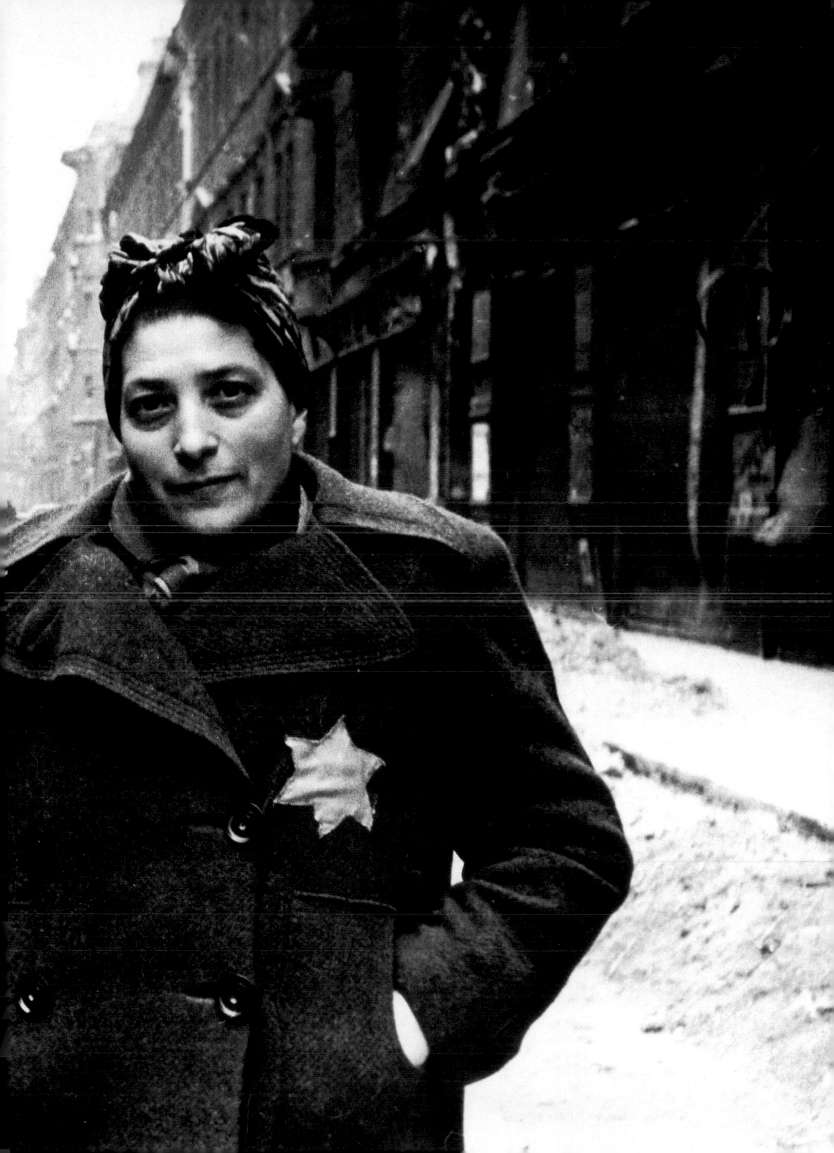

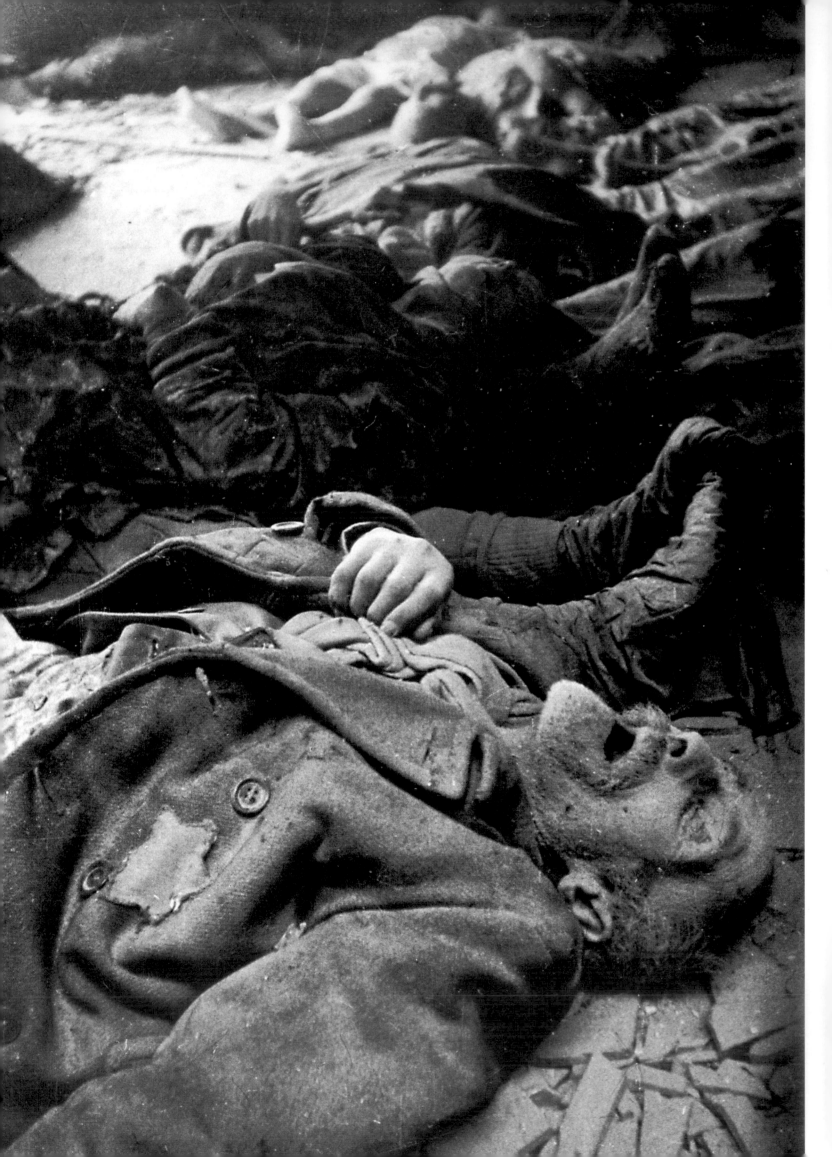

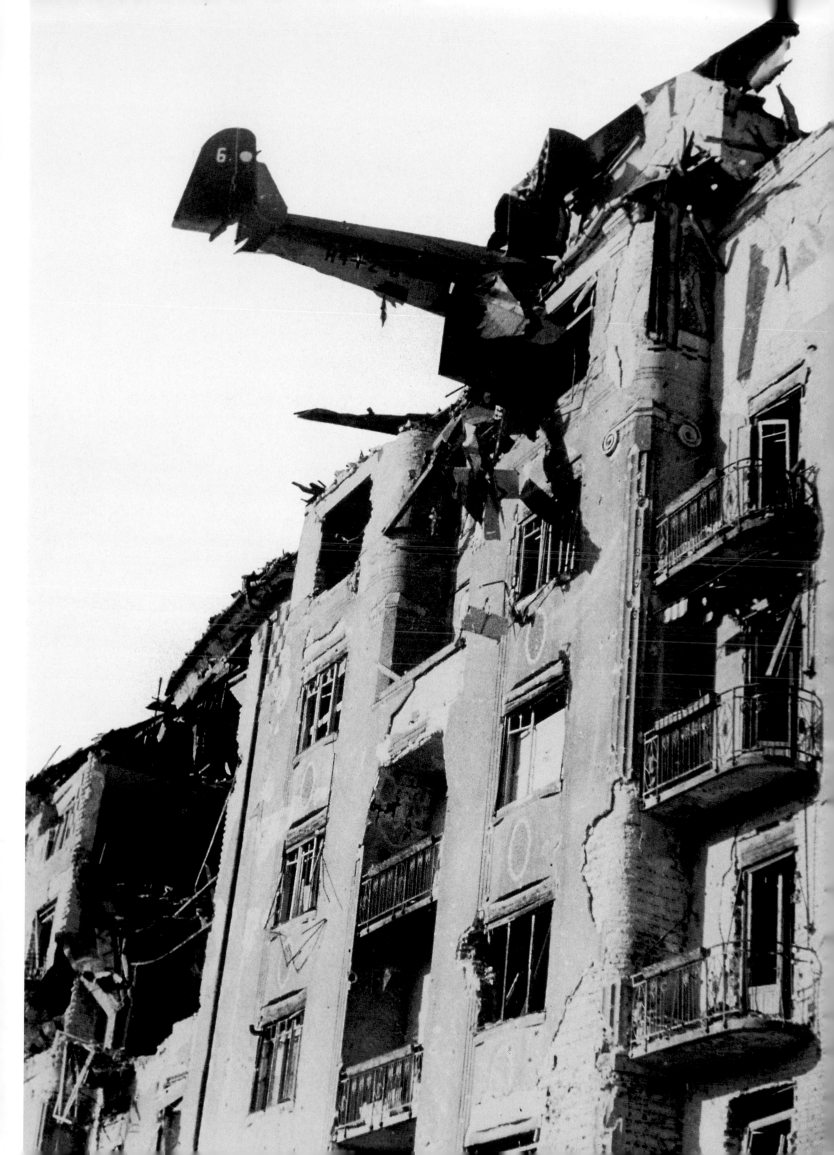

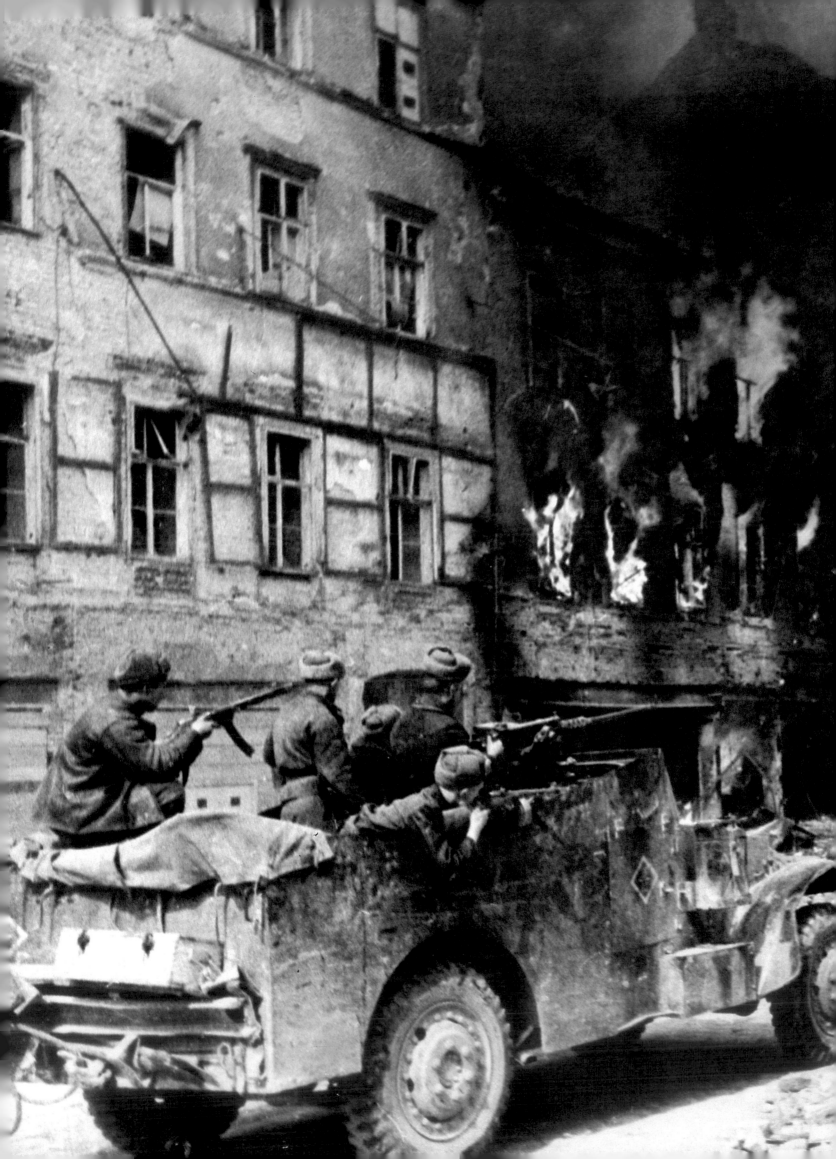

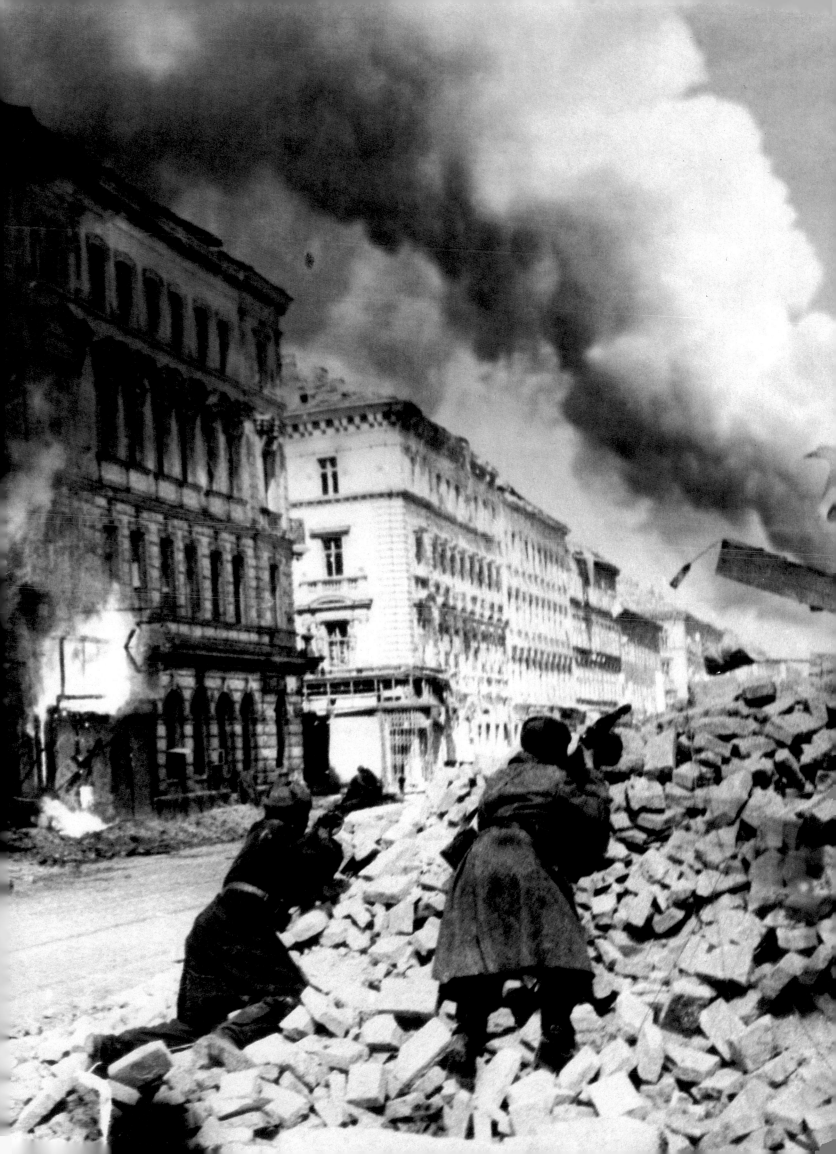

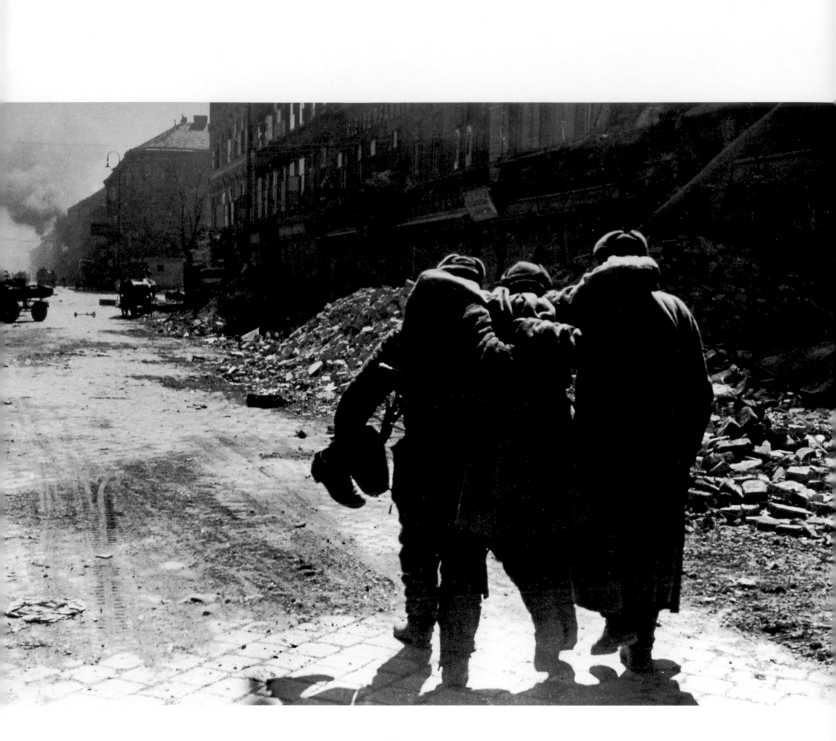

When you photograph a soldier who is coming toward you, the soldier sees the camera and his only thought is, "How am I going to look in this photograph?" But when you photograph a soldier from the back, you can see his real thoughts: "Am I going to live until tomorrow? Where am I going to sleep tonight?" You can read all his thoughts from his back.

Above: Wounded friends, Vienna, February 1945. *Opposite*: Suicide of a Nazi family, Vienna, 1945. *Pages 56–57*: Road to Berlin, 1945.

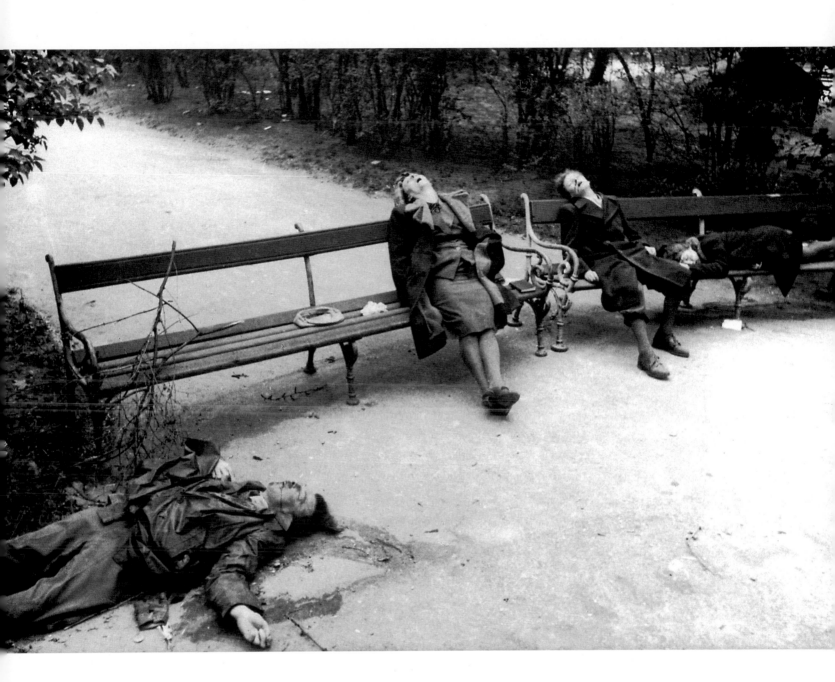

Early in the morning I was passing by the Parliament building and came across this scene. A man was lying on the ground with a revolver next to him. On the bench was a woman, a boy around seventeen, and a fourteen-year-old girl. Next to me was a Soviet officer. A guard came running out of the Parliament and explained what had happened. Very early that morning, despite the shooting that was still going on, a man came to the bench with his whole family. He sat his wife, his son, and his daughter on the bench. He shot his wife and his son. His daughter tried to free herself, but he pushed her down and shot her too. Then he shot himself.

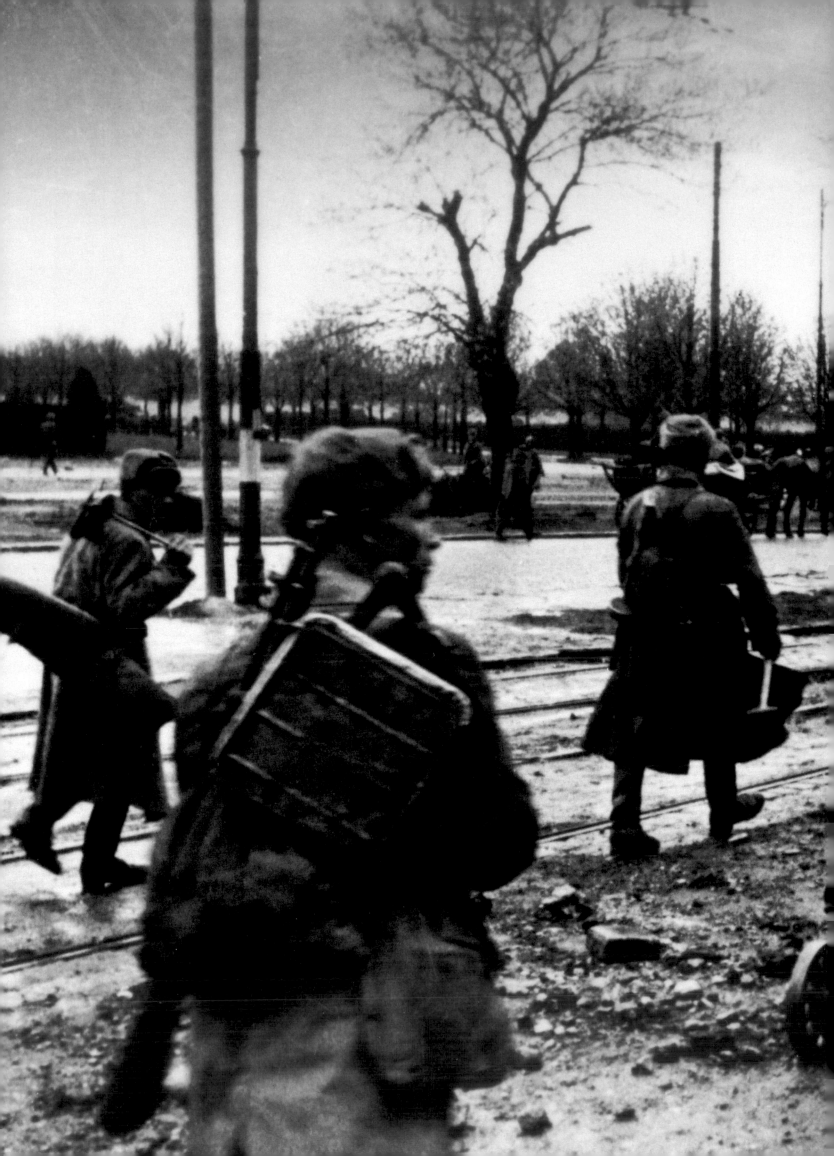

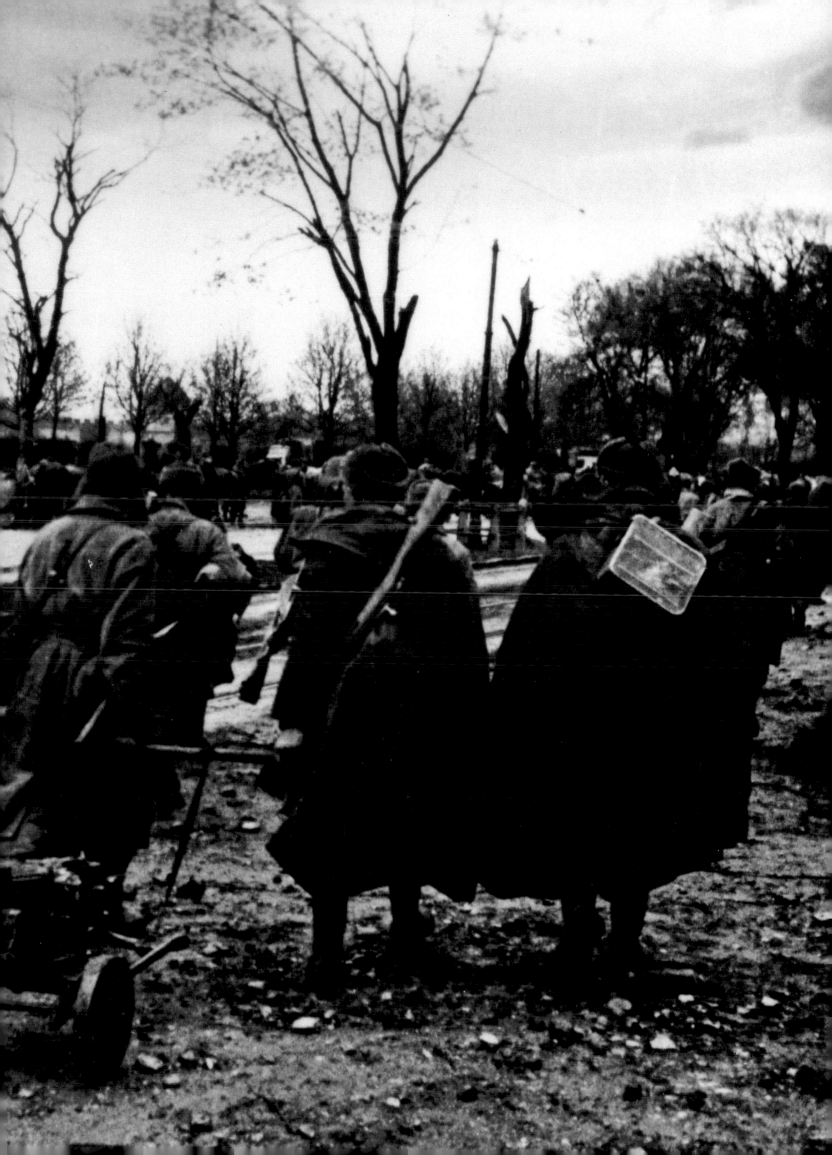

BERLIN

The taking of Berlin had both real and symbolic importance. Stalin had wanted it captured by May 1, an important date in the Communist calendar. To make that date, and not incidentally, to prevent the Americans from getting there first, Marshals Zhukov and Konev engaged in a race that took a heavy toll in Russian lives. The Reichstag and Reichschancellery fell to Marshal Zhukov on May 2.

On the May holiday itself, Khaldei was on the road to Berlin with General Chuikov's 8th Army. The radiant soldier below was one of many traffic directors. American memoirists have often noted how surprised they were to see young women doing this work. The job was dangerous, particularly because the women were not allowed to leave their posts under any circumstances. Khaldei remained in touch with this soldier, Maria Shalneva, long after the war was over, photographing her in honor of the twentieth and thirtieth anniversaries of the victory.

Just before the assault on Berlin, Khaldei made a brief trip to Moscow. He asked his friend—a tailor, Israil Solomonovich Kishitser, in whose room he had been living when war was announced—to sew him three Soviet flags.

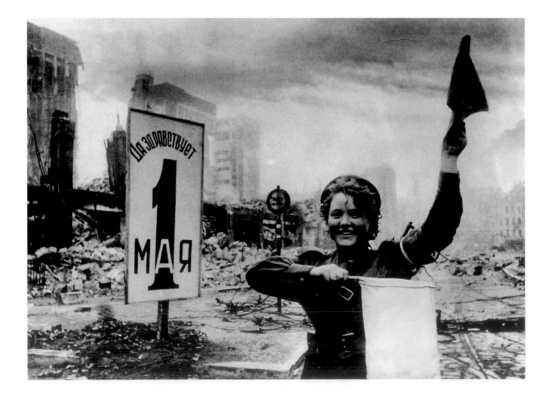

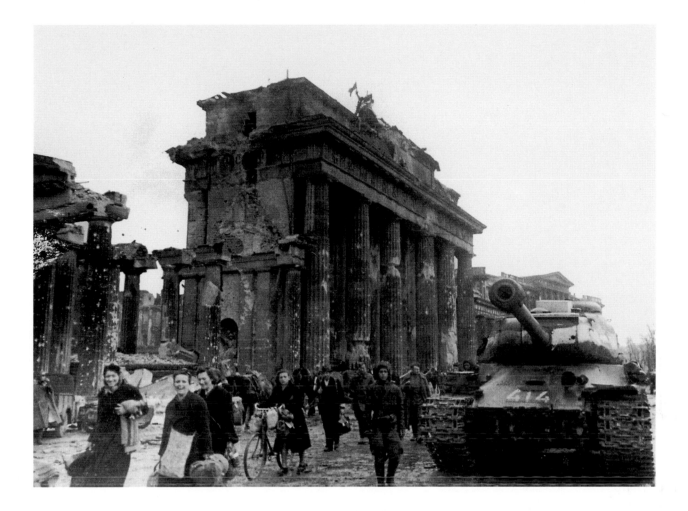

Kishitser made the flags out of red tablecloths, stolen for the occasion from a government office. The next day, Khaldei was flown back to Berlin:

With those three flags I went to Berlin. Before they freed the Reichstag, they liberated the airport at Tempelhof. On the roof of the airport building was a huge eagle. There I put my first flag. At the Brandenburg gate I took my second picture. And then came the Reichstag. I ran onto the roof together with the soldiers, and looked for a good angle. The soldiers already had the flag, but I couldn't decide where to take the picture. Then I found my spot, and I told the soldier, "Alyosha, climb up there." And he said, "Okay, if somebody holds me by the feet."

Opposite: Road to Berlin, May 1, 1945. *Above*: Berlin, May 2, 1945. *Pages 60–61*: Reichstag, Berlin, May 2, 1945.

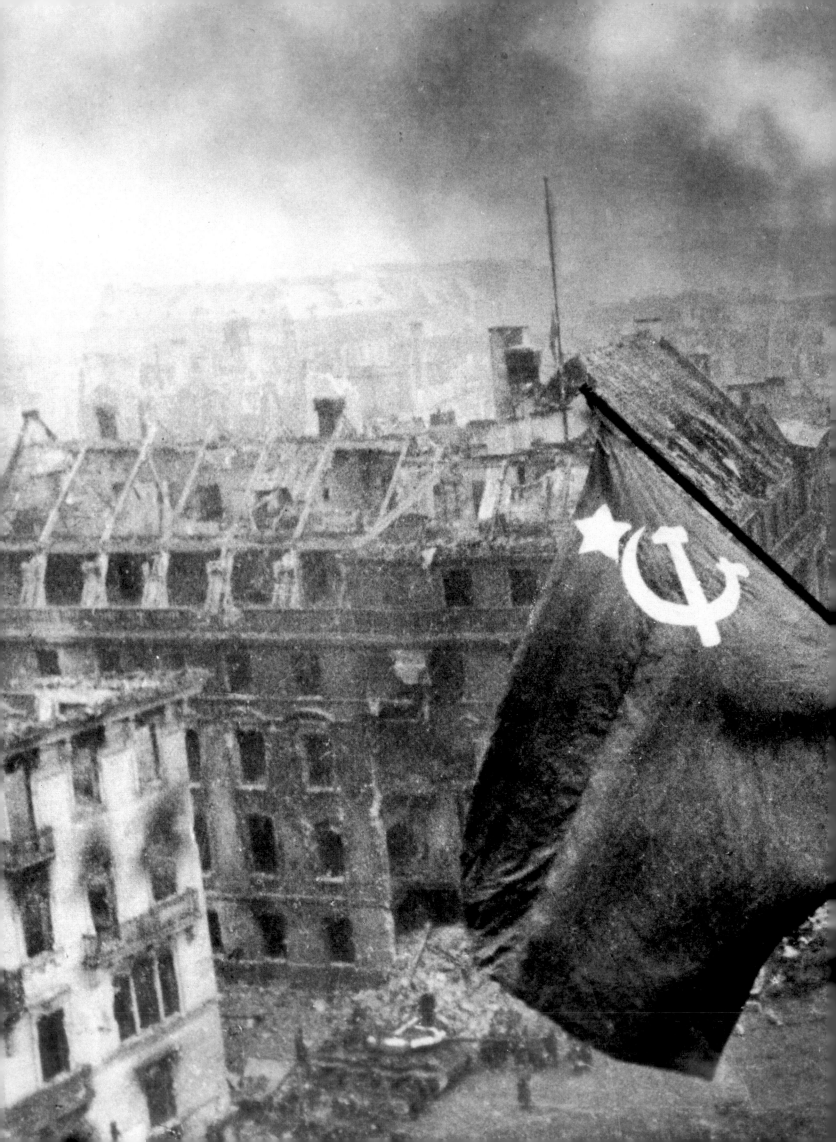

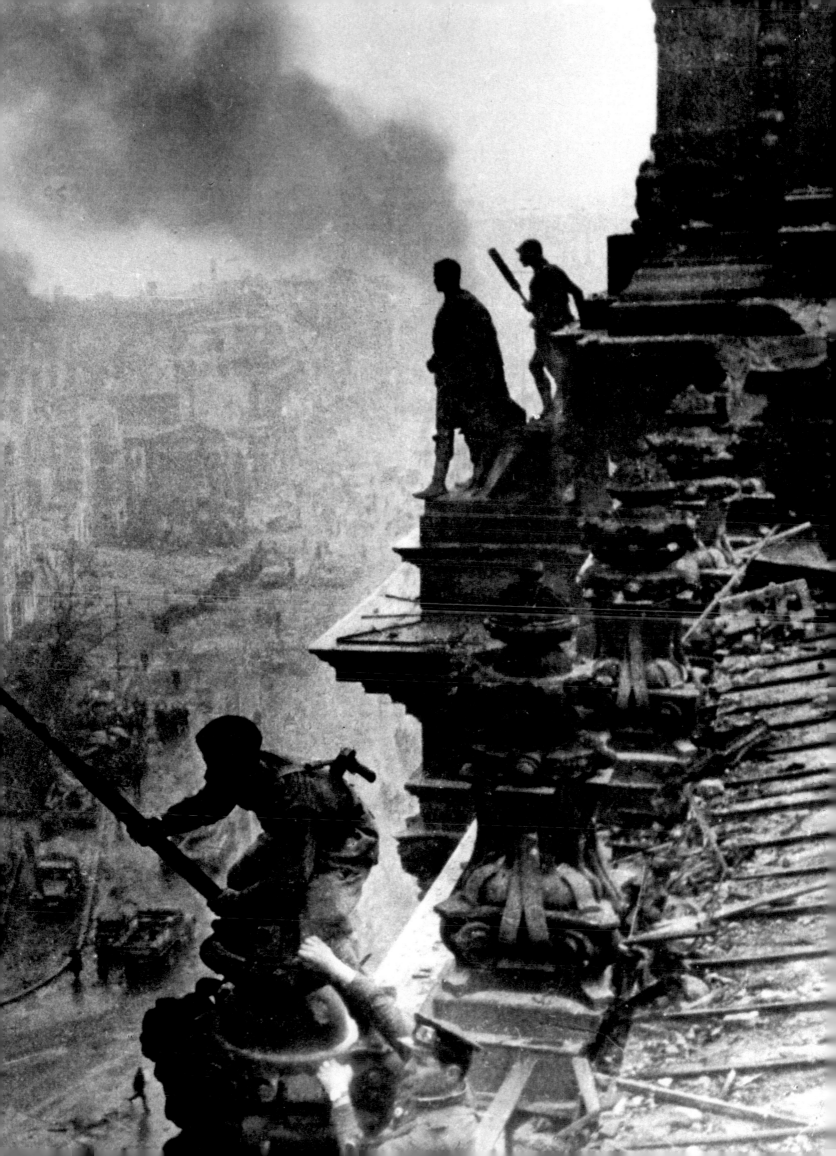

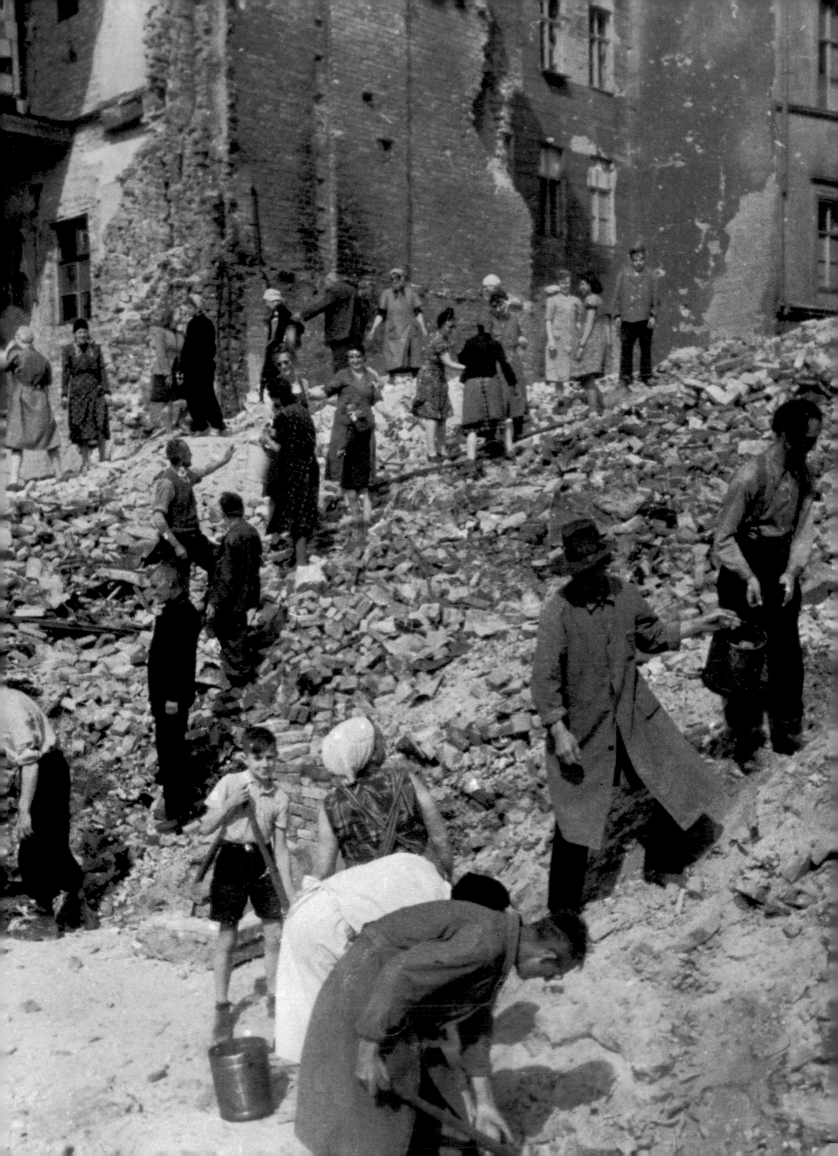

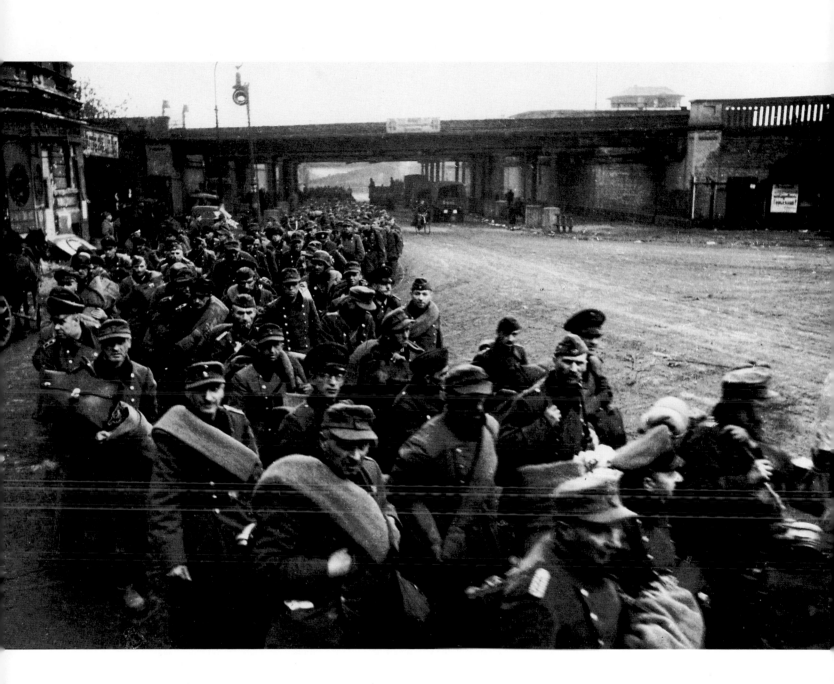

Opposite: Germans clearing rubble, Berlin, 1945. *Above*: German prisoners of war, Berlin, May 1945. *Page 64*: Poet Yevgeny Dolmatovsky, Berlin, May 2, 1945. *Page 65*: Tempelhof Airport, Berlin, April 1945. *Pages: 66–67*: Berlin, June 1945. Field-Marshal Montgomery presents medals to Marshals Zhukov and Rokossovsky. Behind Rokossovsky are Generals Malinin and Sokolovsky.

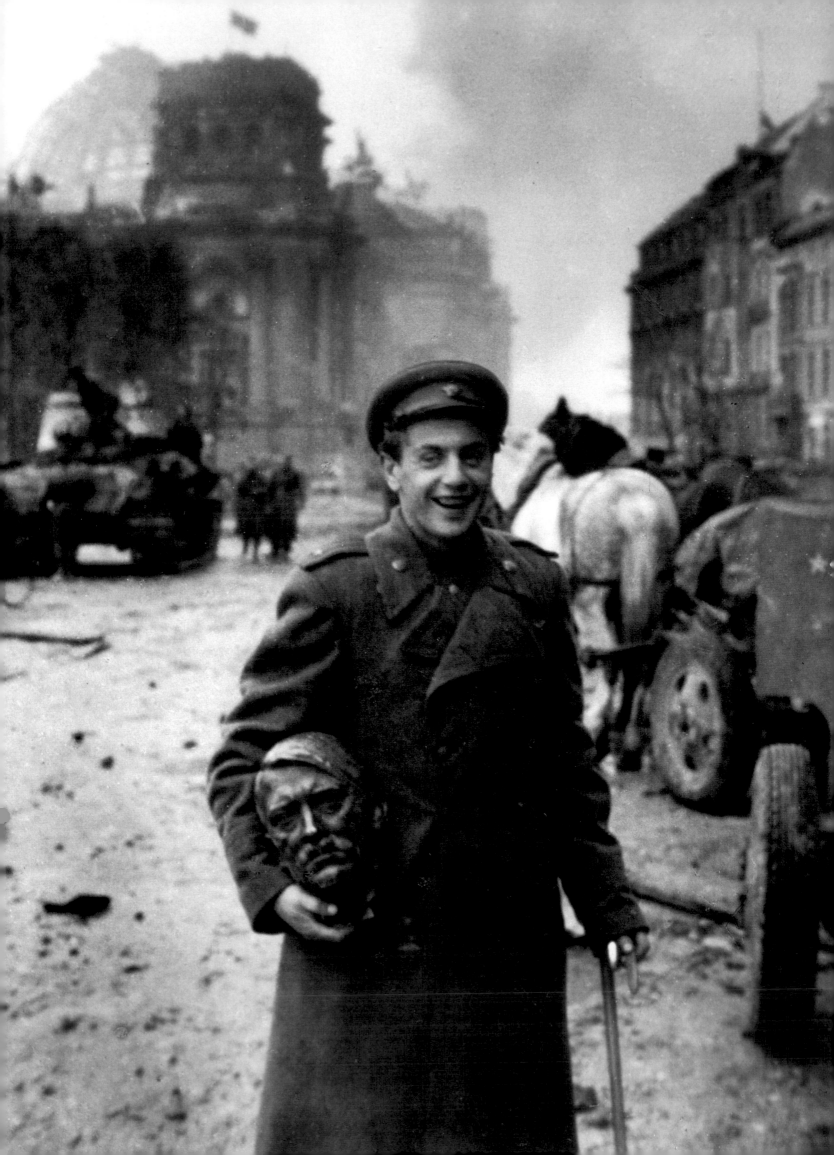

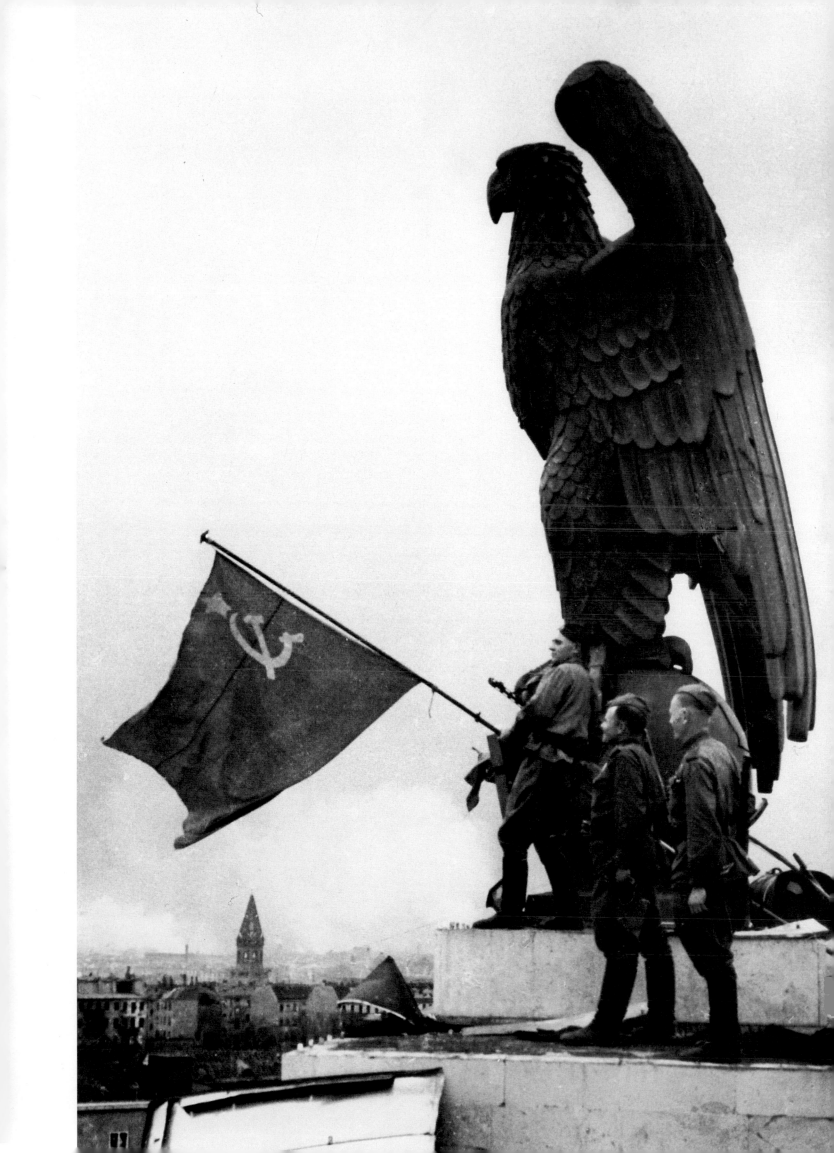

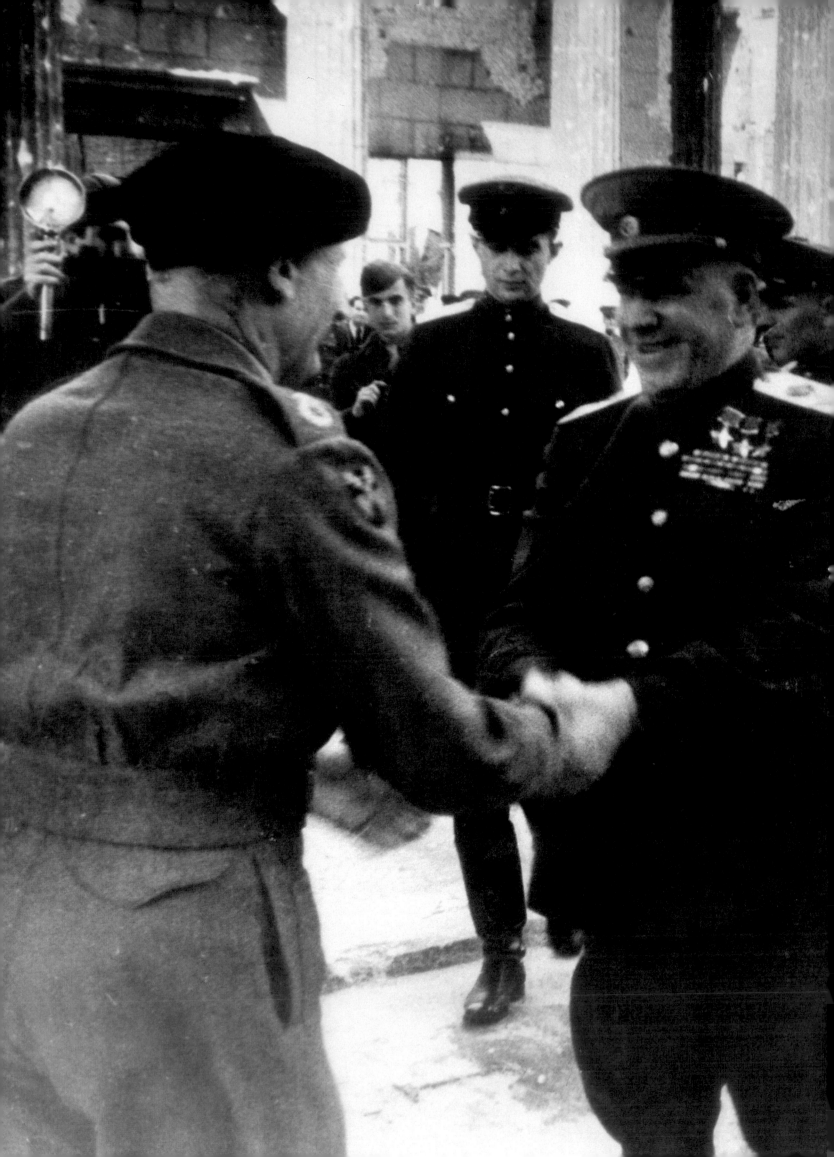

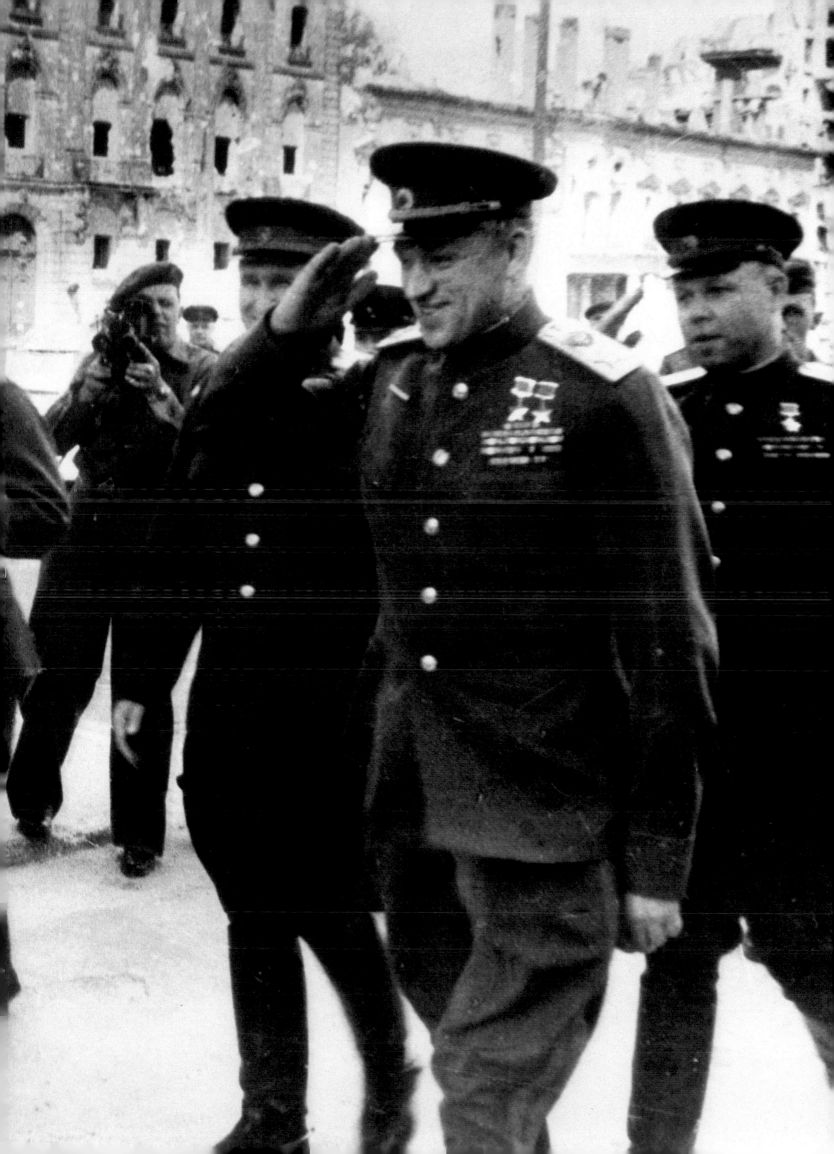

VICTORY DAY, MOSCOW, JUNE 24, 1945

Victory Day in Russia is celebrated on May 9, the date of the formal German surrender to Zhukov in Berlin. (Americans celebrate on May 8, on the date of Jodl's capitulation to Eisenhower at Rheims. Stalin complained that Soviet representation at Rheims was not sufficiently high-ranking.) Preparations for that first celebration took almost two months. Time was needed to choreograph the event, and just as important, to ensure that the victorious generals could all be present. June 24 turned out to be cold, with a driving rain.

As part of the ceremony, Soviet soldiers cast down two-hundred Wehrmacht standards. The allusion was to the victory over Napoleon, when French standards were cast at the feet of Alexander I. This time the soldiers stood in front of Lenin's tomb.

At the height of the ceremony, Marshal Zhukov rode across Red Square on a white horse. It is said that Stalin wanted the honor for himself, but got thrown in rehearsal. Zhukov was a former cavalryman. He was very proud of Khaldei's photograph.

Opposite: Victory parade, Red Square, Moscow, June 24, 1945. *Pages: 70–71*: Marshal Zhukov, Red Square, Moscow, June 24, 1945. *Page 72*: Red Square, Moscow, June 24, 1945. *Page 73*: Third Ukrainian Front, Red Square, Moscow, June 24, 1945.

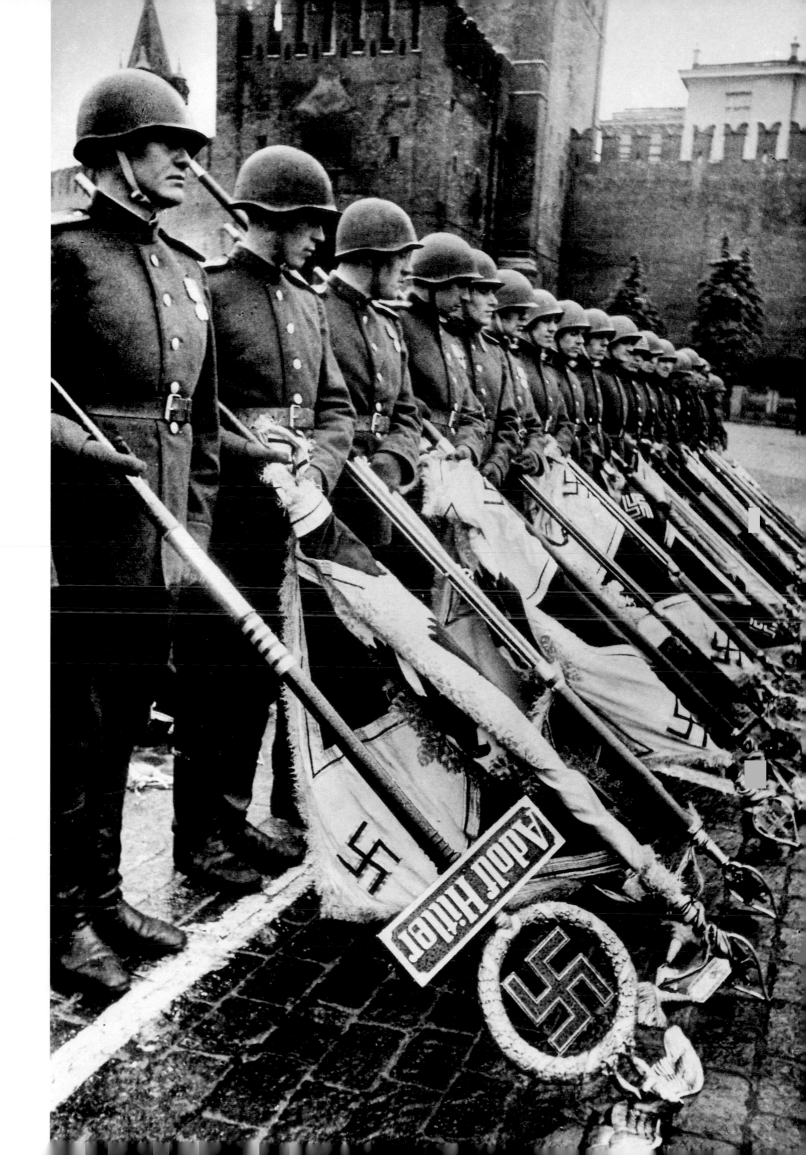

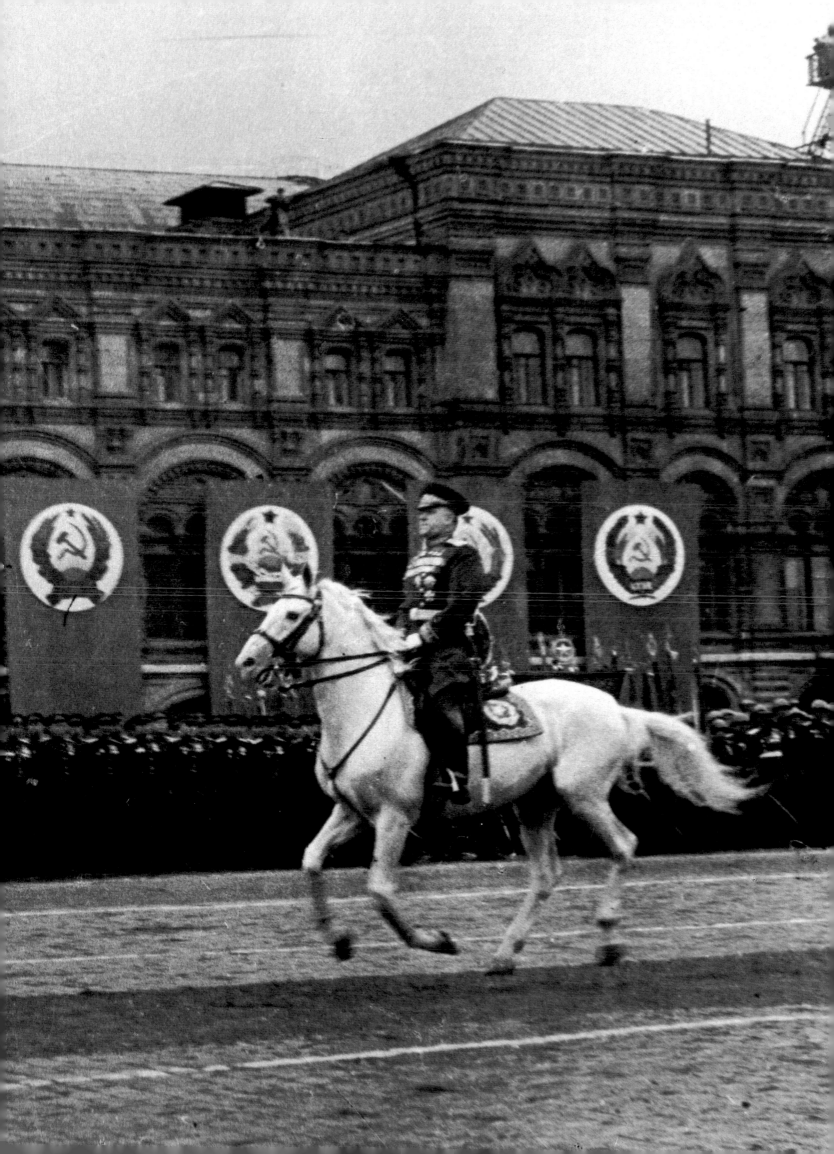

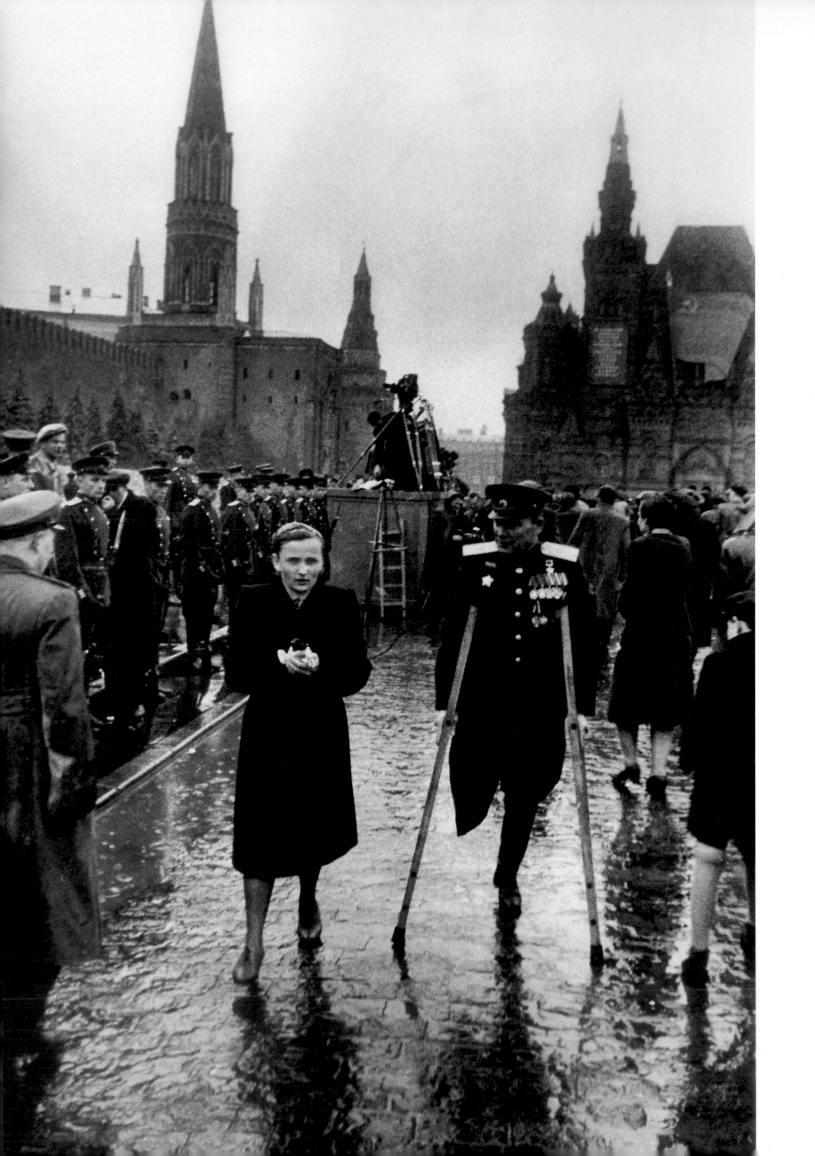

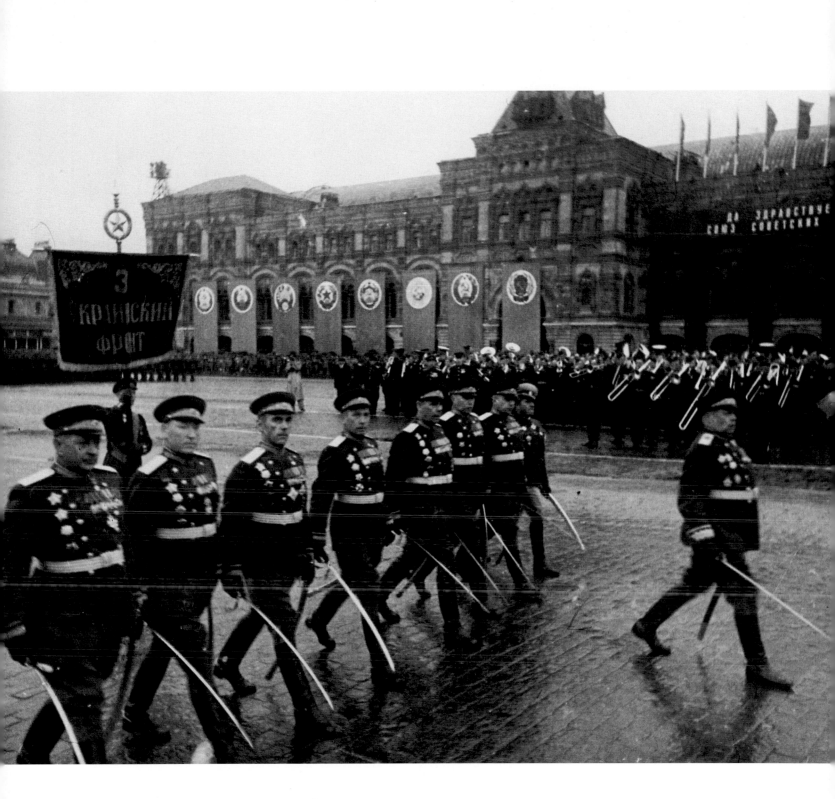

The marching soldiers are from Khaldei's own "beloved Third Ukrainian" Front. The Third Ukrainian was involved in the liberation of Sevastopol; later, under the command of Marshal Tolbukhin, it broke through Romania, Yugoslavia, Hungary, and Austria. All the time that Khaldei spent in Sevastopol and then in Eastern Europe and the Balkans, he was with this Front. The general out front is Tolbukhin, whom Khaldei greatly admired.

In addition to the joy of victory, Khaldei marked its sadness. At the parade's end, a one-legged general slowly makes his way home.

PEACE

When the postwar conferences began, Khaldei was twenty-eight years old and at the top of his profession. At Nuremberg, the Soviet wing of the press camp was called the *Khaldeinik*, and its inhabitants *Khaldeans*. Since "Khaldei" in Russian means "Chaldee," the term lent a Biblical ring to conversations about housing:

"Where are you living?"
"Well, obviously we're Khaldeans," *said Nikolai, mildly offended at the question.*
(From Boris Polevoi's *V kontse kontsov*.)

As photographer to the political elite, Khaldei trained his lens on the Big Three—Truman, Churchill, and Stalin. There was also time for high spirits: when the Big Three vacated their wicker chairs (opposite, bottom) Khaldei and two friends had themselves photographed in the prestigious seating.

The Luxembourg Palace, below, was the site of the Paris Peace Conference in 1946. There were sessions from which the press was excluded. Finding himself outside, Khaldei photographed the delegates' hats (opposite, top).

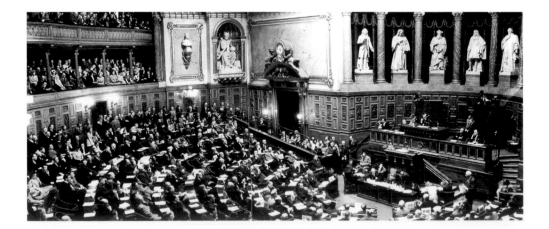

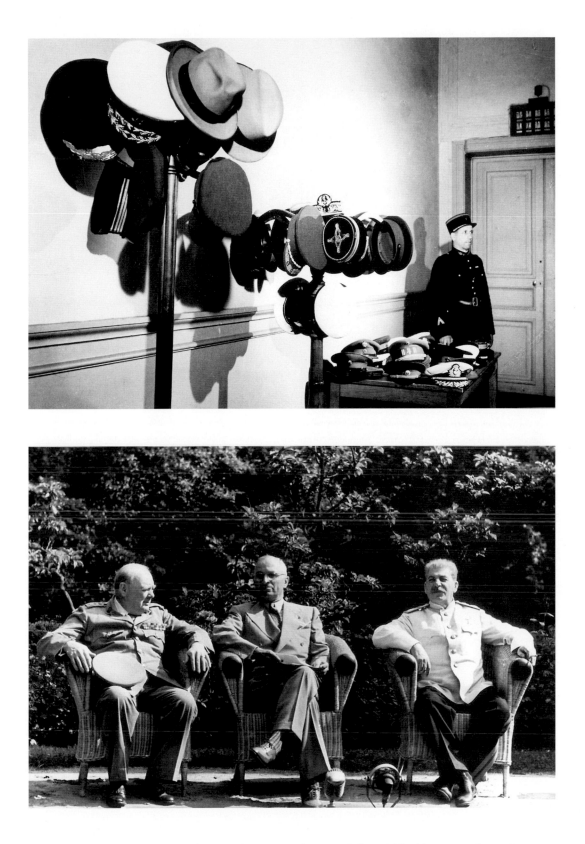

Opposite: Luxembourg Palace, Paris Peace Conference, July, 1946. *Above top*: Paris Peace Conference, July, 1946. *Above bottom*: The Big Three at Potsdam, July, 1945: Churchill, Truman, and Stalin. *Pages 76–77*: Truman and Stalin, Potsdam, July, 1945. *Pages 78–79*: Potsdam, July, 1945. *Pages: 80–81*: Potsdam, July, 1945.

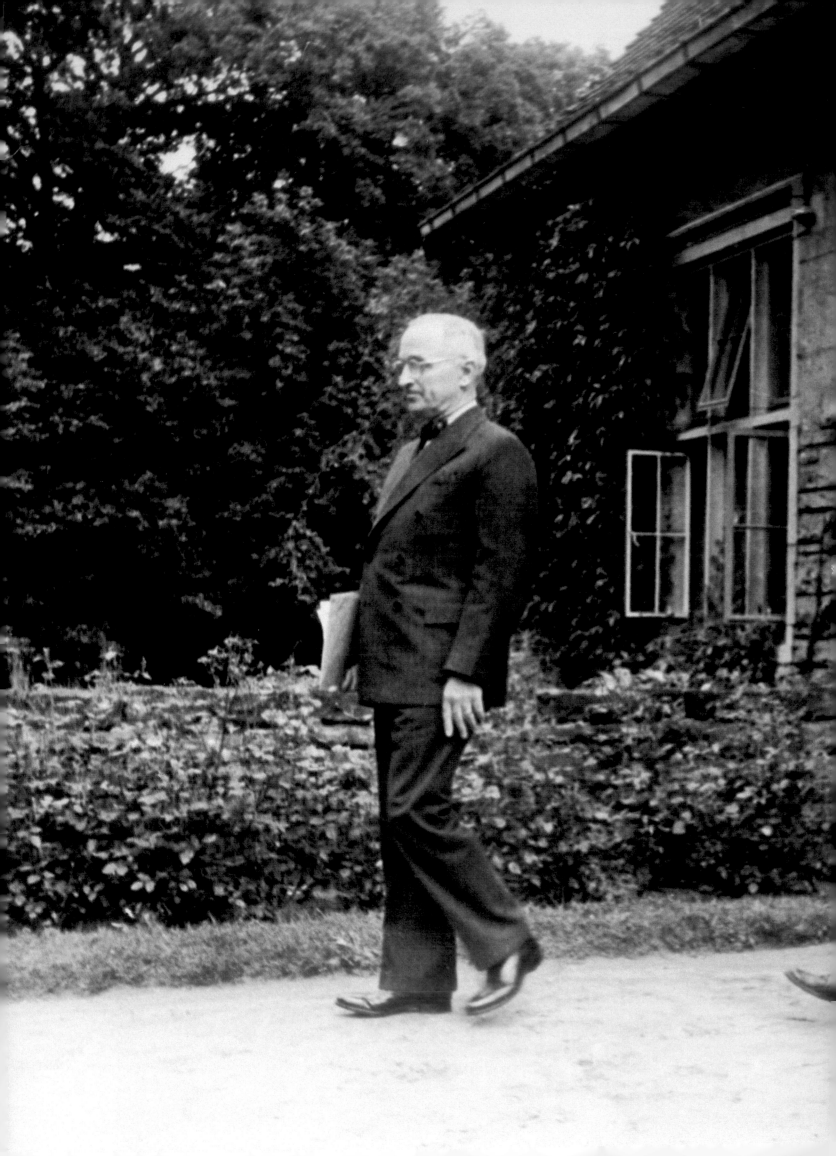

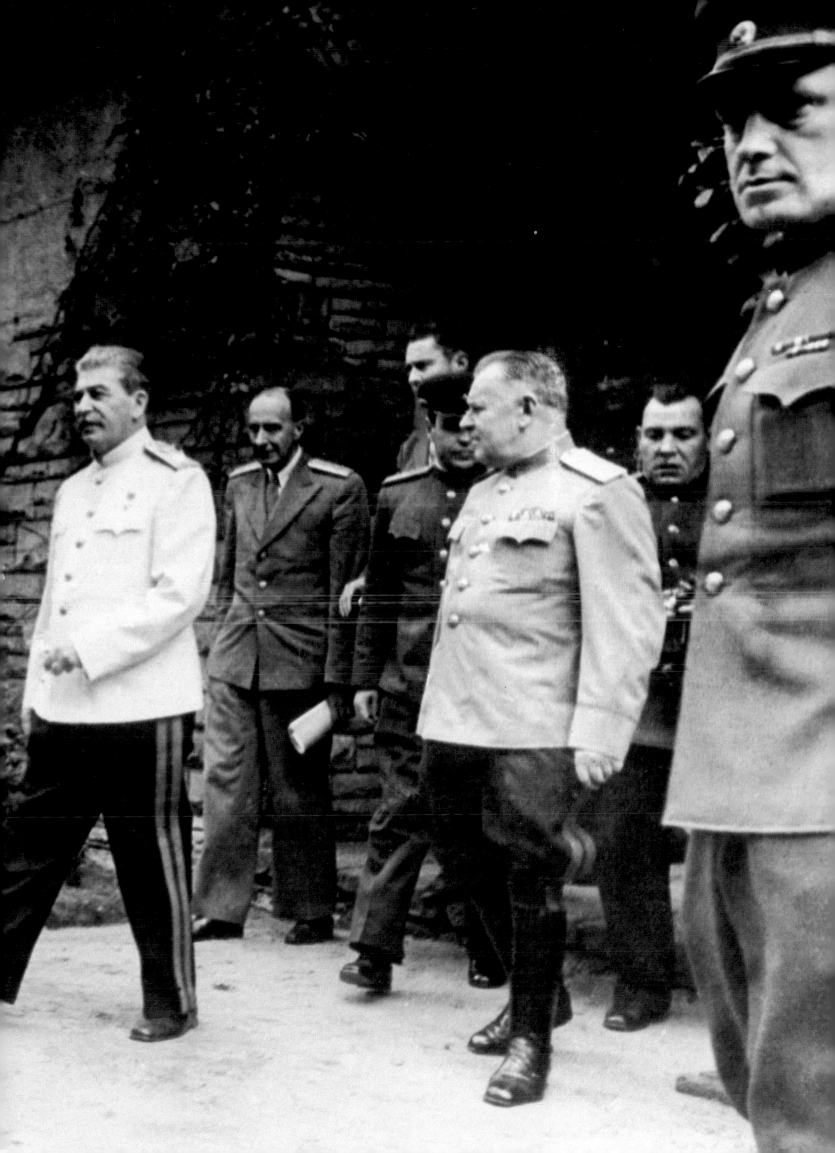

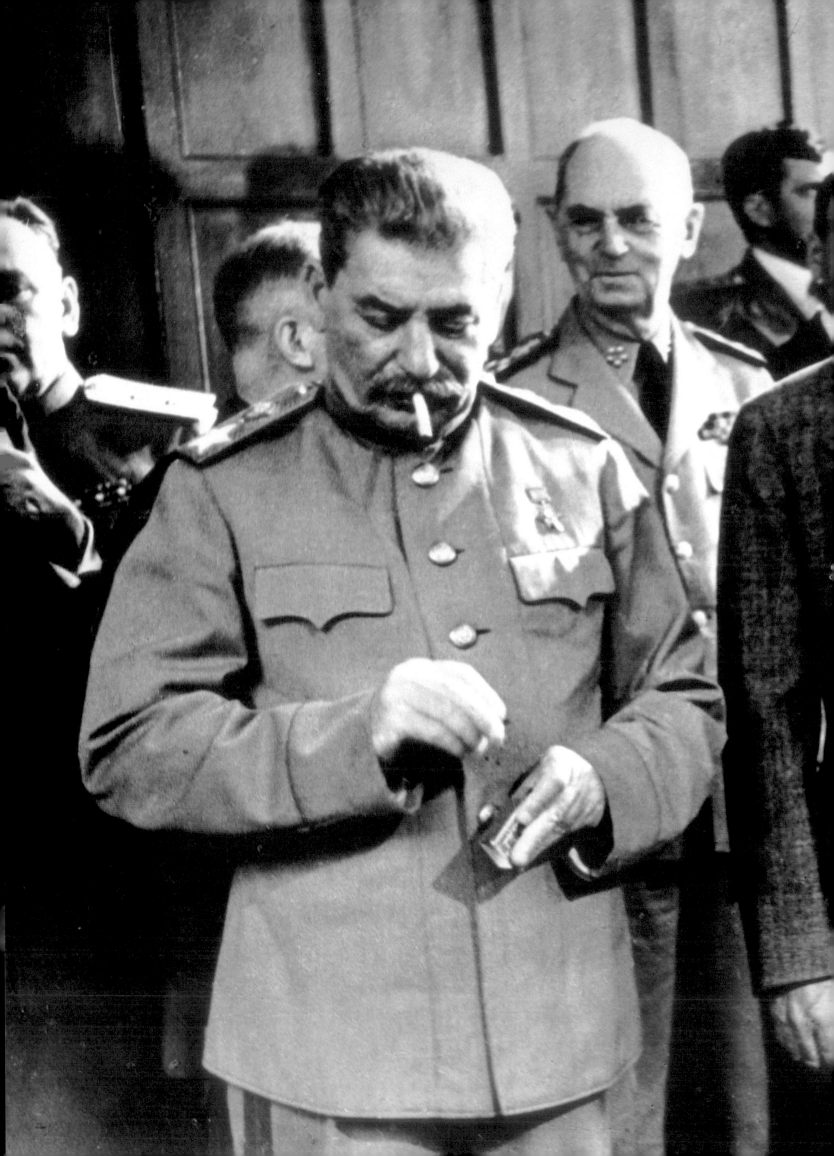

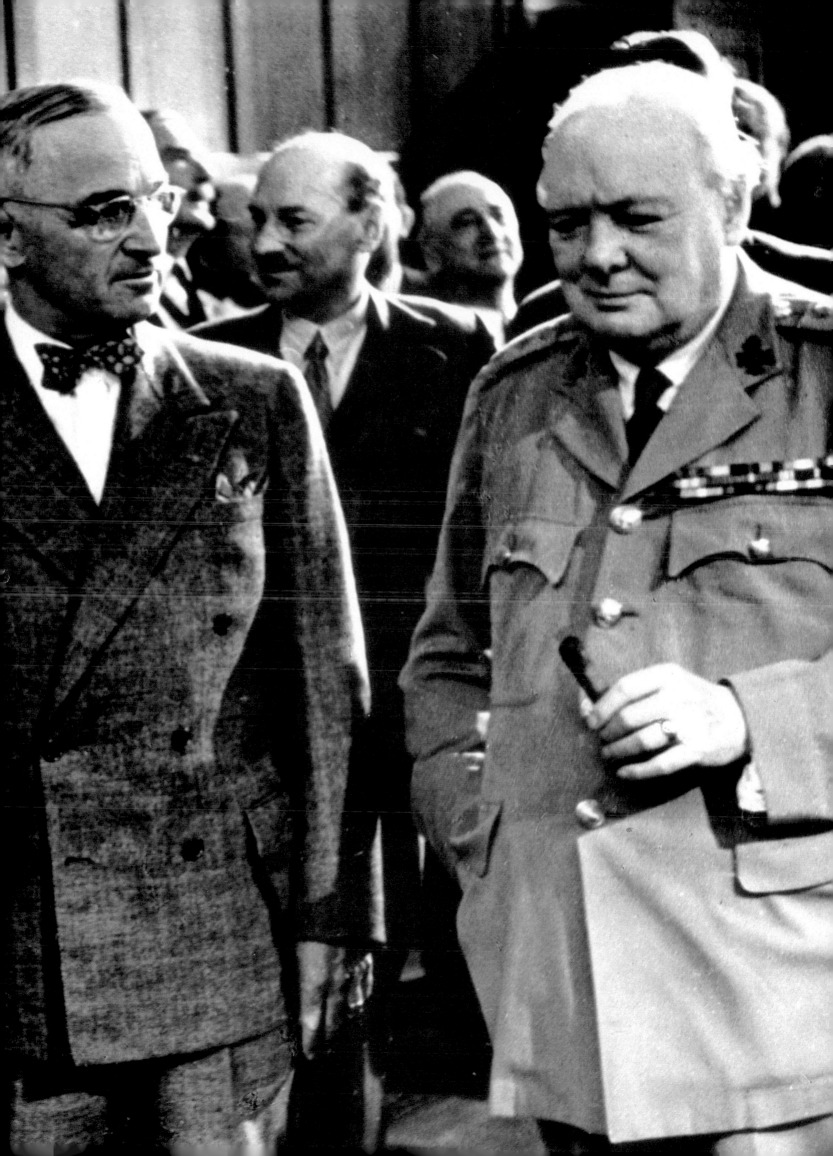

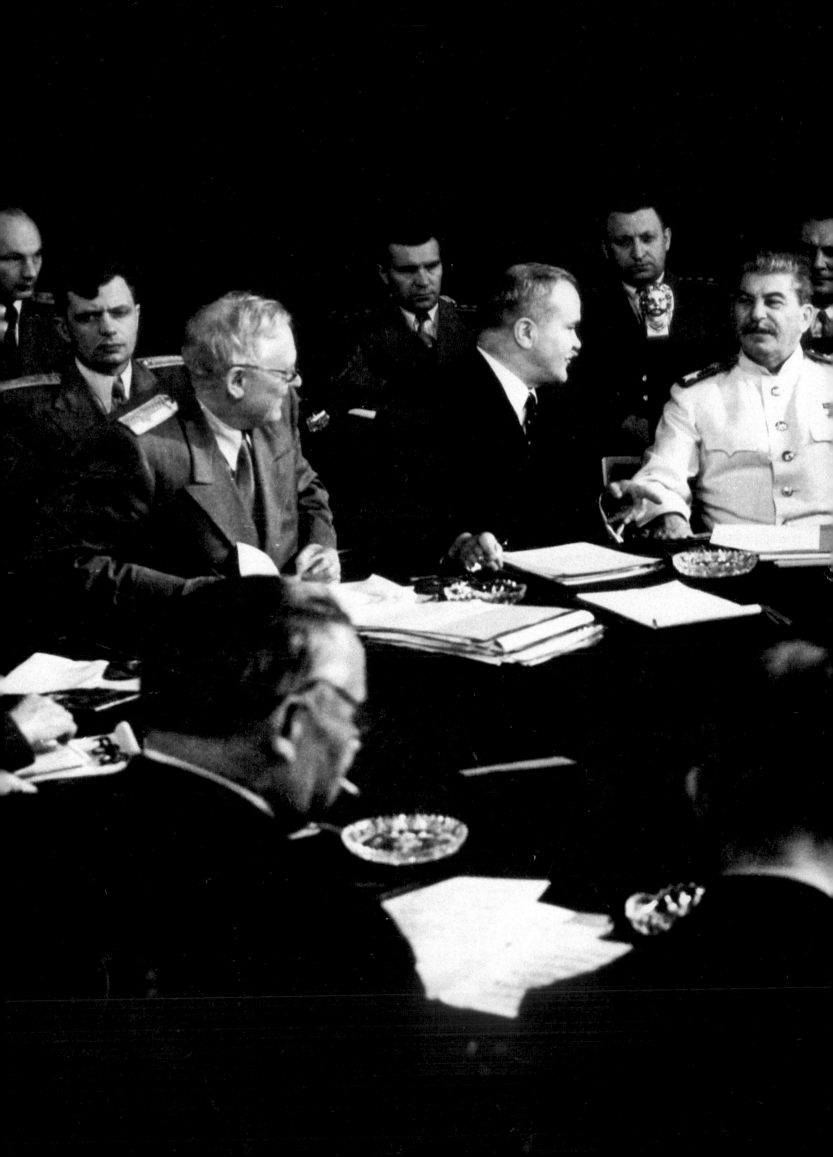

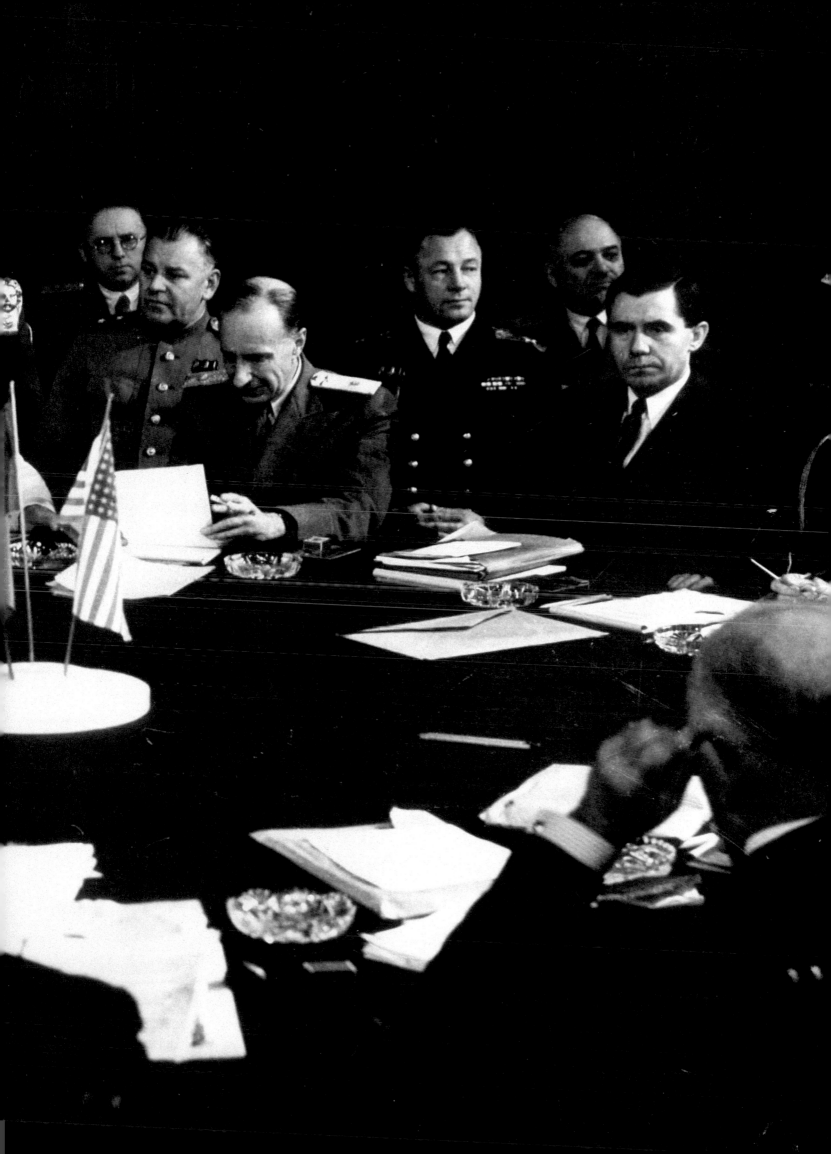

NUREMBERG

Khaldei's frequent subject was Goering. He pursued him from various angles, at one point changing places with a guard to get a better view. The cost of that maneuver was a bottle of vodka—though on a different occasion, an American MP came to Khaldei's aid unasked, slapping the camera-shy Nazi into submission. Goering tolerated photographers from other nations, but Khaldei, in his Soviet navy uniform, was for him beyond the pale. A few days after the incident with the MP, Khaldei wanted his picture taken with Goering. Seeing what was about to transpire, Goering hid his head in his hands (below).

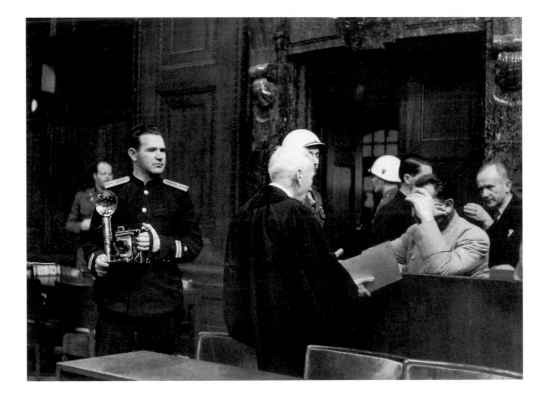

Above: Khaldei and Goering, Nuremberg, 1946. *Opposite*: Nuremberg, 1946. *Pages 84–85*: Goering talks to his lawyer, Nuremberg, 1946. *Pages 86–87*: Nuremberg, 1946.

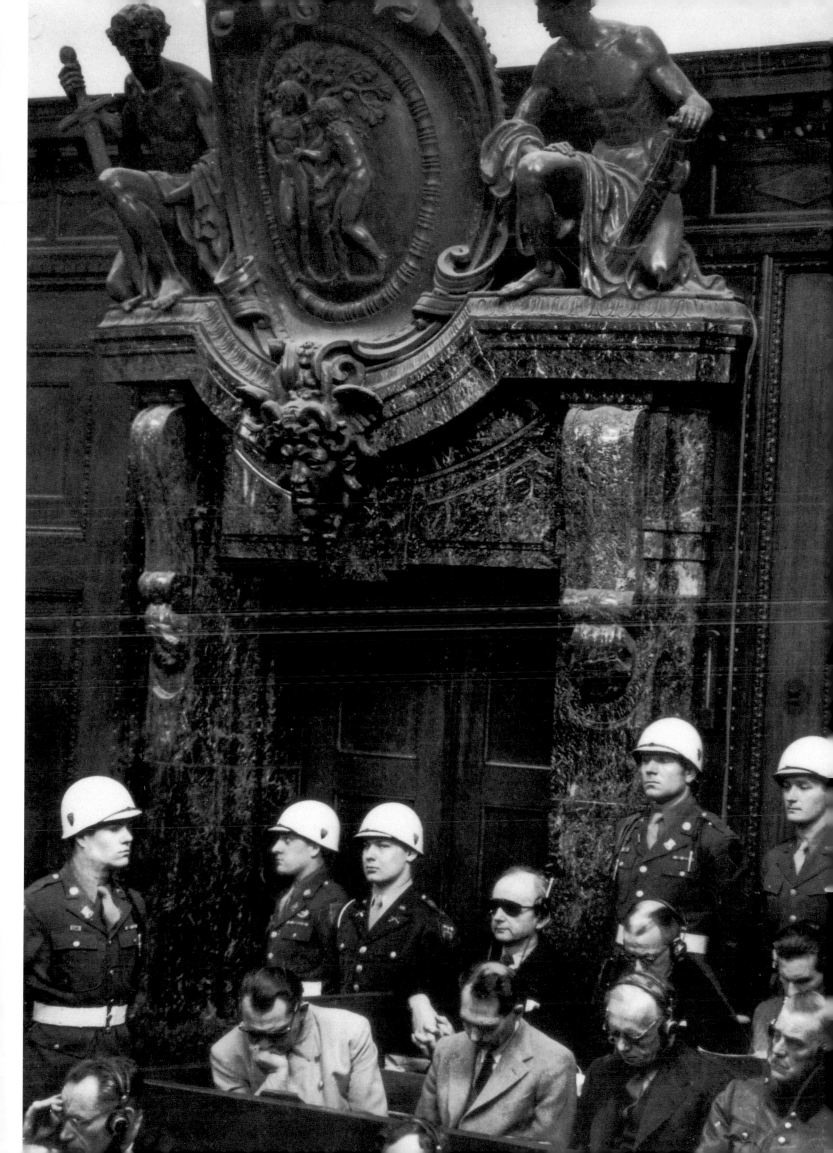

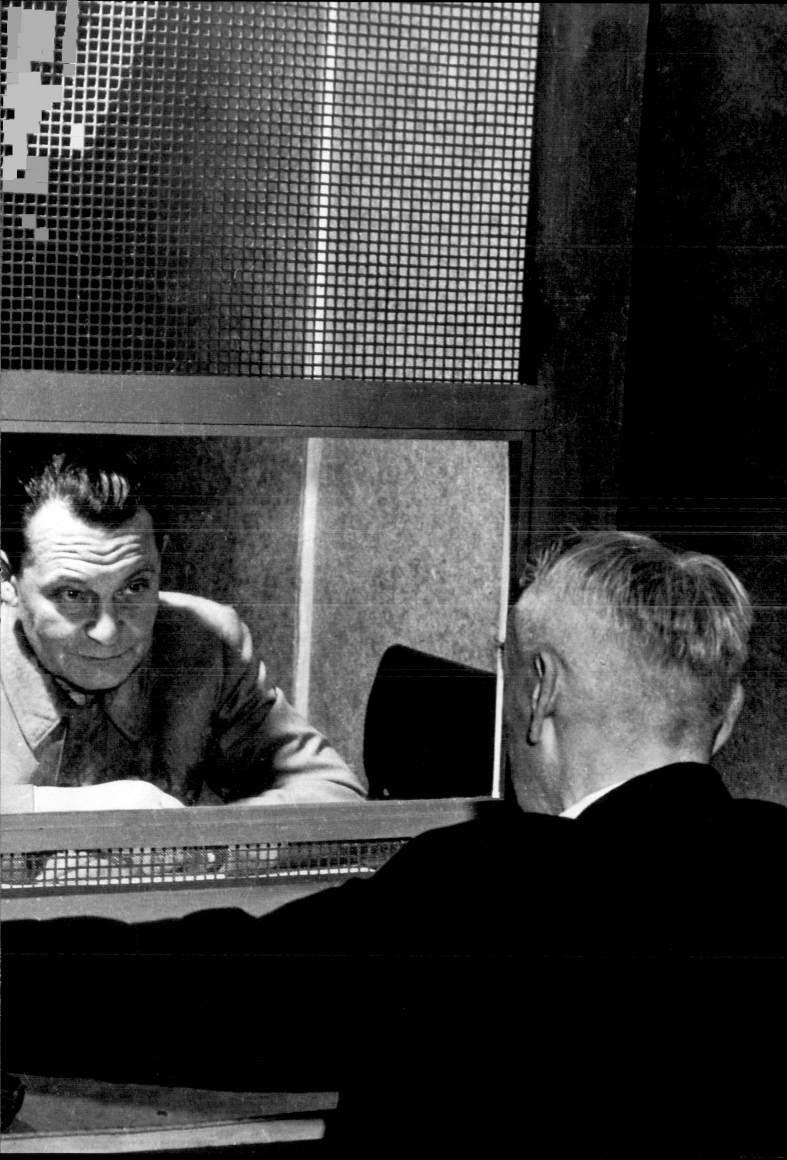

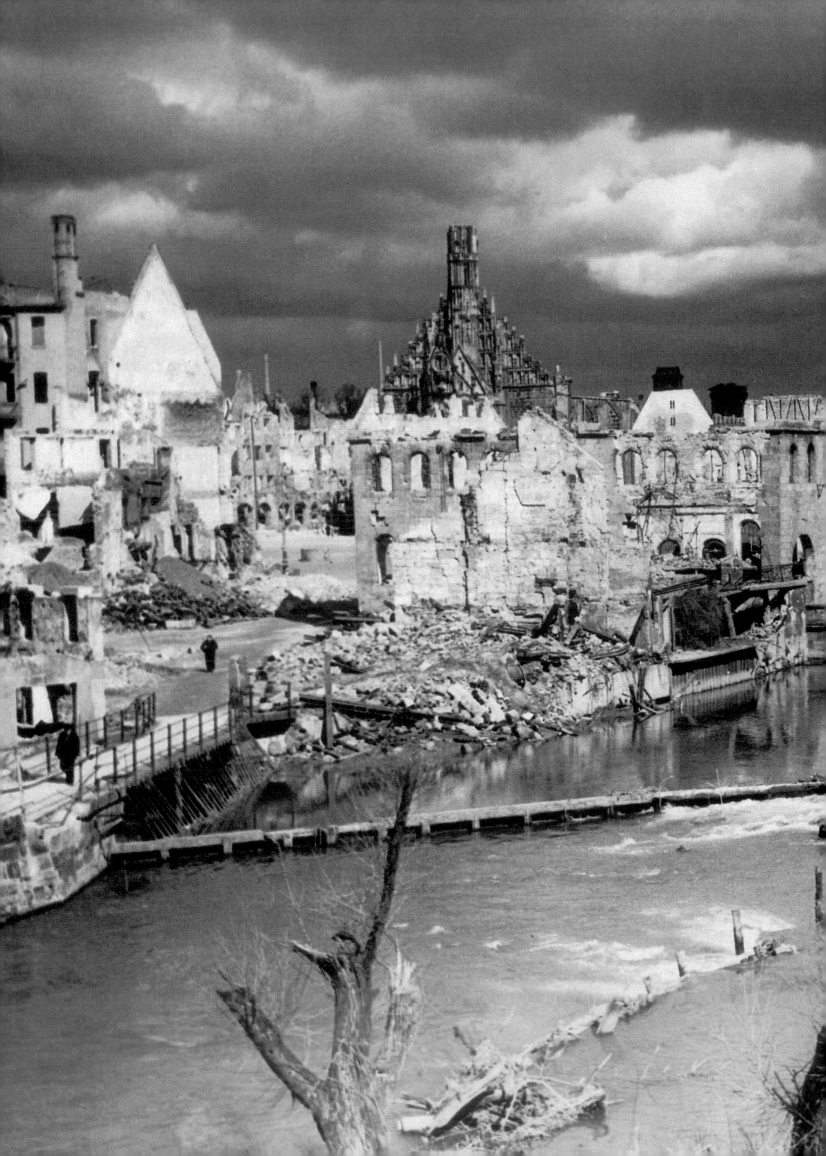

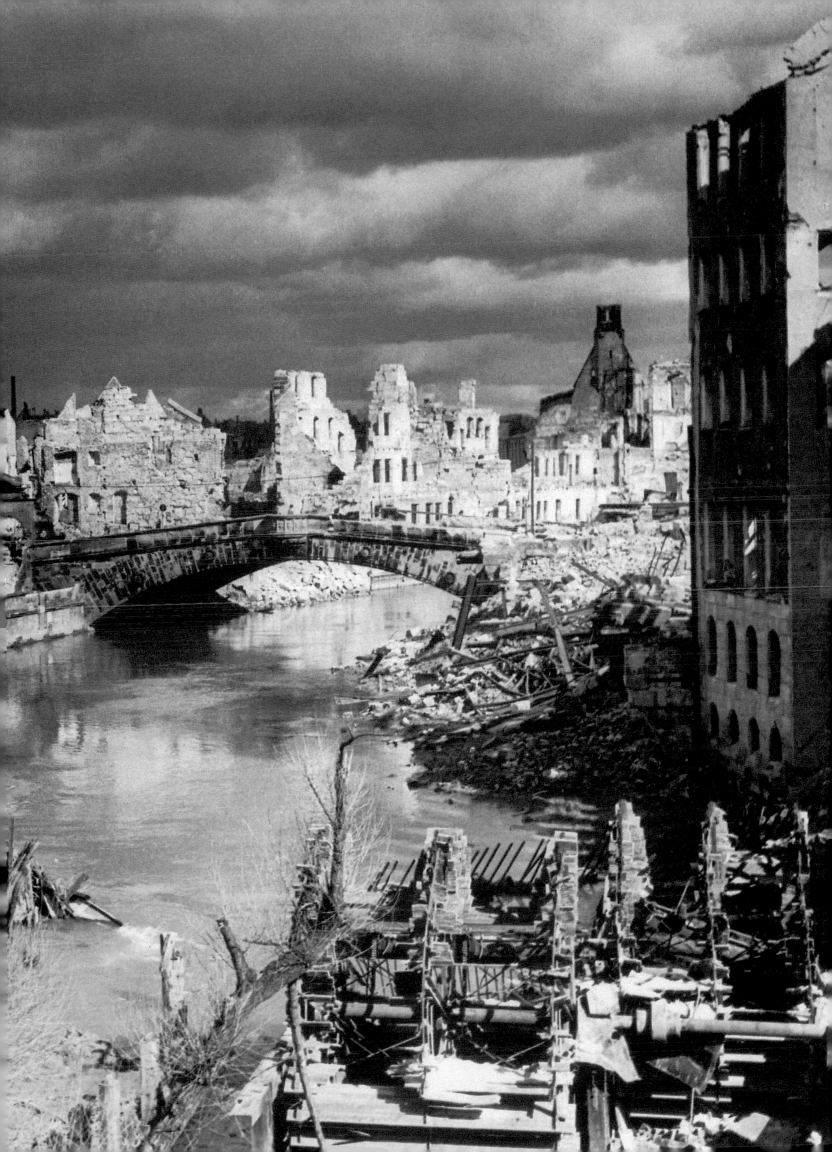

AFTER THE WAR

After immortalizing Stalin in a number of well-known shots, such as *Stalin and child* (page 92), Khaldei was fired from TASS. From 1948 to 1959, when he was taken on by *Pravda*, he made a living through reproductions and work for minor magazines. On their pages, Khaldei says, he "portrayed harmonious human development through photographs of dancing milkmaids."

In some of these images, both before and after 1948, the symbolism is overt. In *Song of Stalin*, below, the costumed singers represent the various Soviet nationalities. The iconlike composition, with a plaster Stalin in the

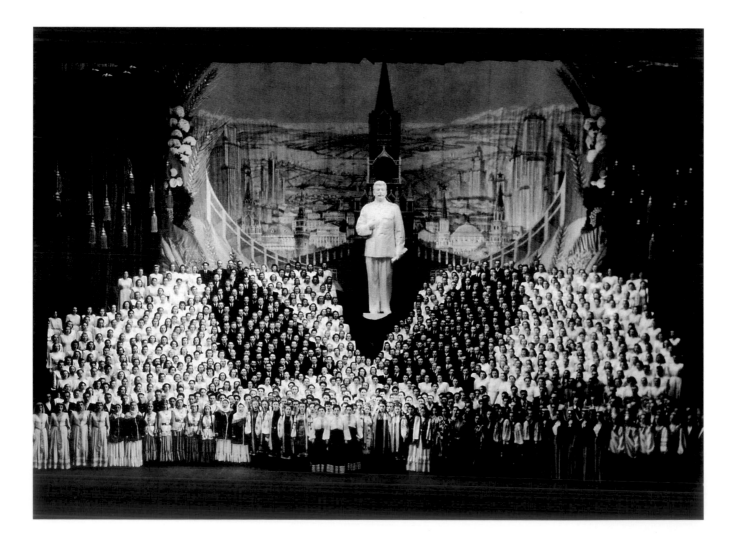

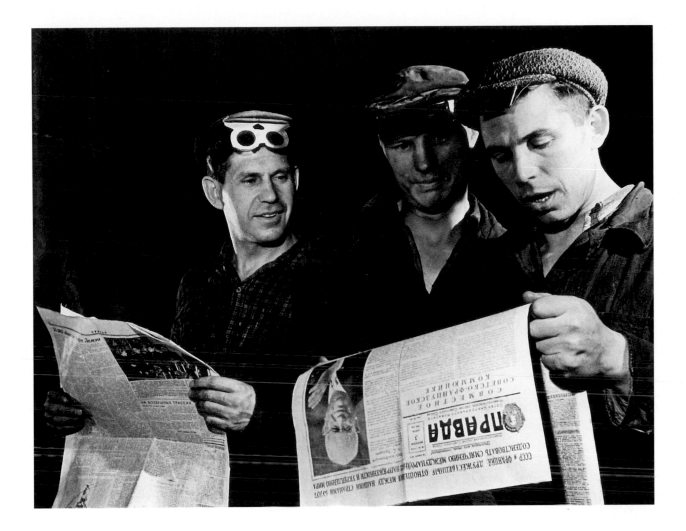

center, recalls the Soviet state emblem. *Workers read the newspaper*, above, is from the *Pravda* years. Sent to prove a point—that Soviet workers are the most politically literate in the world—Khaldei made sure to bring a newspaper with him.

When he could, Khaldei lets us see something else. The portrait of Mstislav Rostropovich shows the cellist at the start of his career, a combination of fragility and self-confidence. Dmitry Shostakovich, by contrast, is all tension (page 91). "They beat him down," says Khaldei. "You could see the pain in his face."

Opposite: Song of Stalin, 1947. *Above*: Hammer and Sickle factory, Moscow, 1960s.

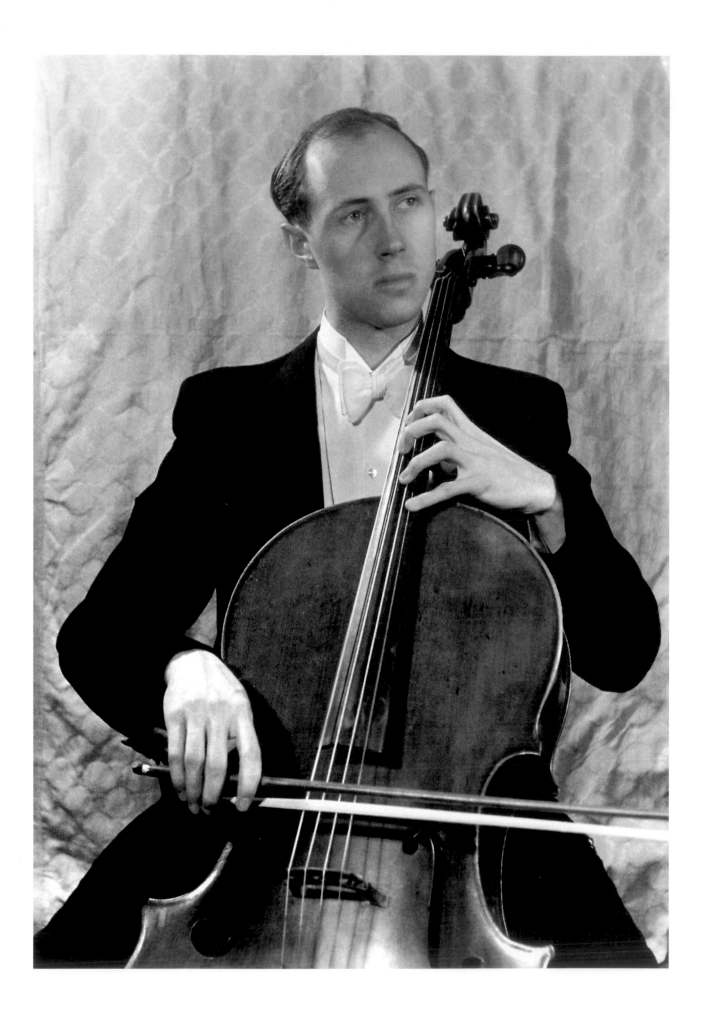

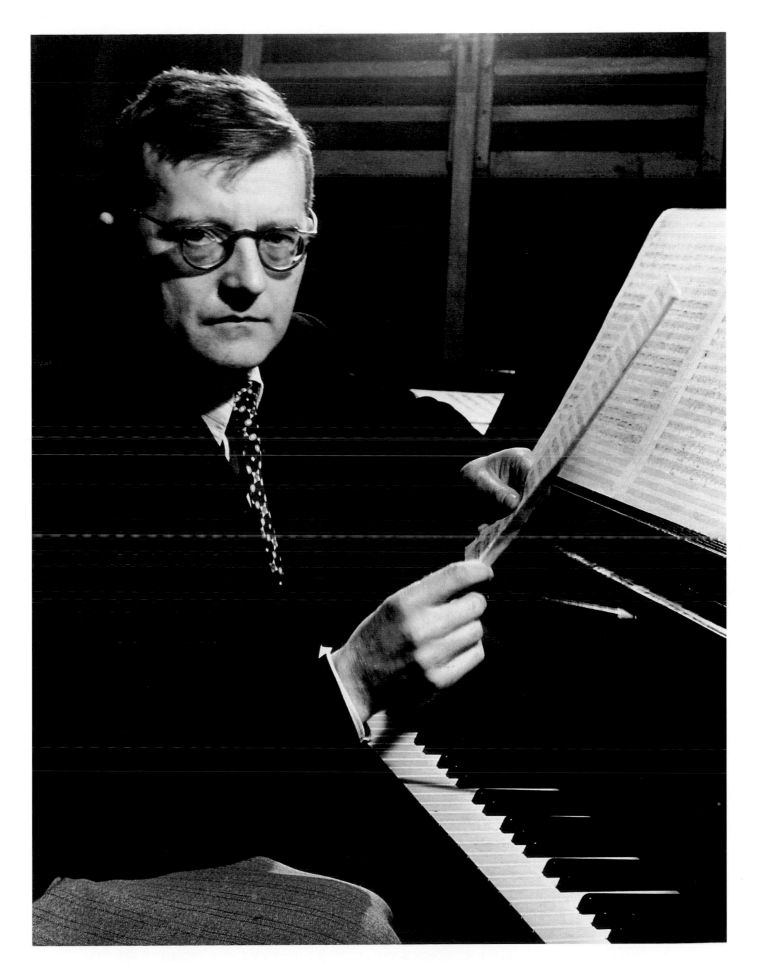

Opposite: Mstislav Rostropovich, Moscow, 1951. Above: Dmitry Shostakovich, Moscow, 1951.

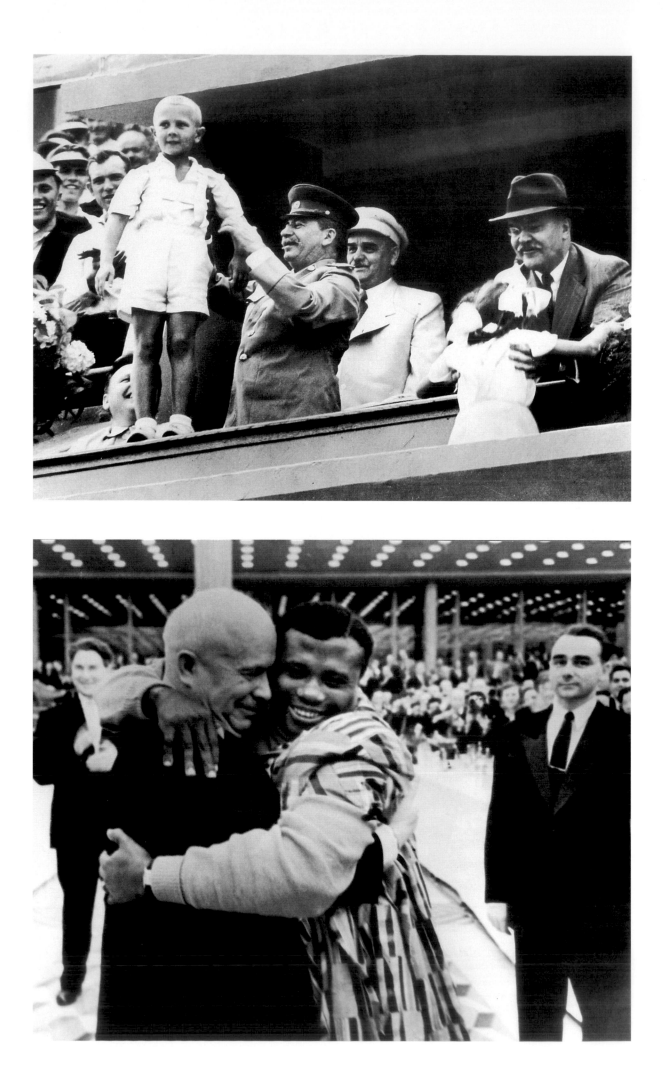

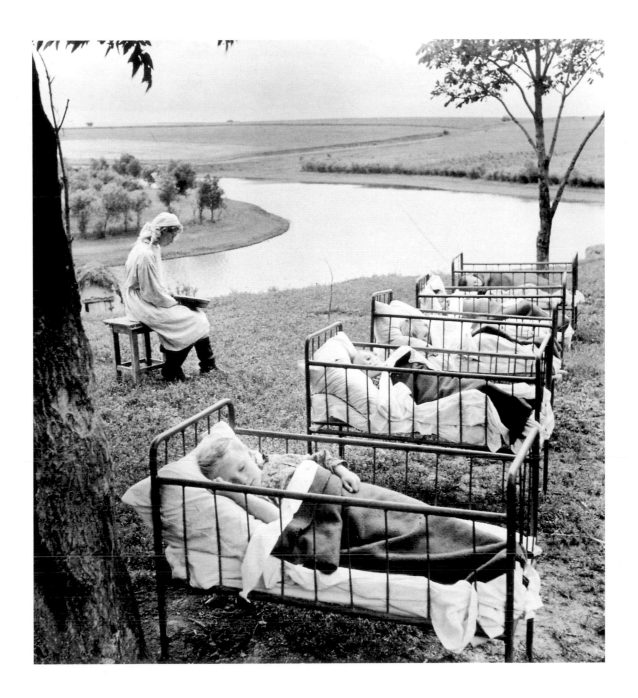

The reality behind this image was the mass exodus of Soviet nursery schools (actually, daycare centers) from the city to the country for the summer months. The young woman watching her sleeping charges could almost be a Madonna, except for her heavy boots. Similar contrasts pervade the photograph, from which a knowledgeable observer could almost extract the principles of Soviet child care. Regimentation is foremost, but it is offset by a certain innocence and a reverence for the outdoors.

Opposite top: Stalin and child, Dynamo Stadium, Moscow, 1946. *Opposite bottom*: Khrushchev hugs African leader, Moscow, 1956. *Above*: Iron cots, Ukraine, 1951.

Within months of the victory parade, Stalin began building a case against Zhukov. There were searches of his apartment and dacha. Finally he was accused of political unreliability, and moved to an unimportant post. Zhukov returned to the Kremlin under Khrushchev, whom he helped bring to power, but Khrushchev also feared his popularity and eventually forced his retirement. In the large history of the war published under Khrushchev, Zhukov's leadership is minimized. In 1972, Zhukov invited Khaldei to his dacha. He wanted a large print of the image Khaldei had taken of him in 1945 (see pages 70–71). While there, Khaldei took this portrait—it was to be Zhukov's last.

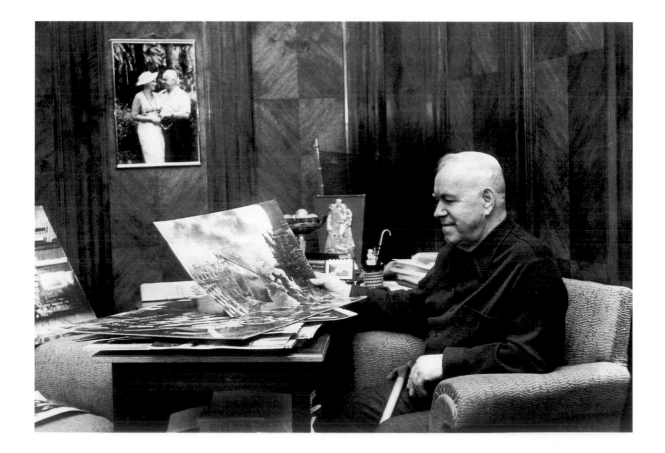

Above: Zhukov at his Sosnovka dacha, November 1972. *Opposite*: The last official May 1 celebration, Moscow, 1990.

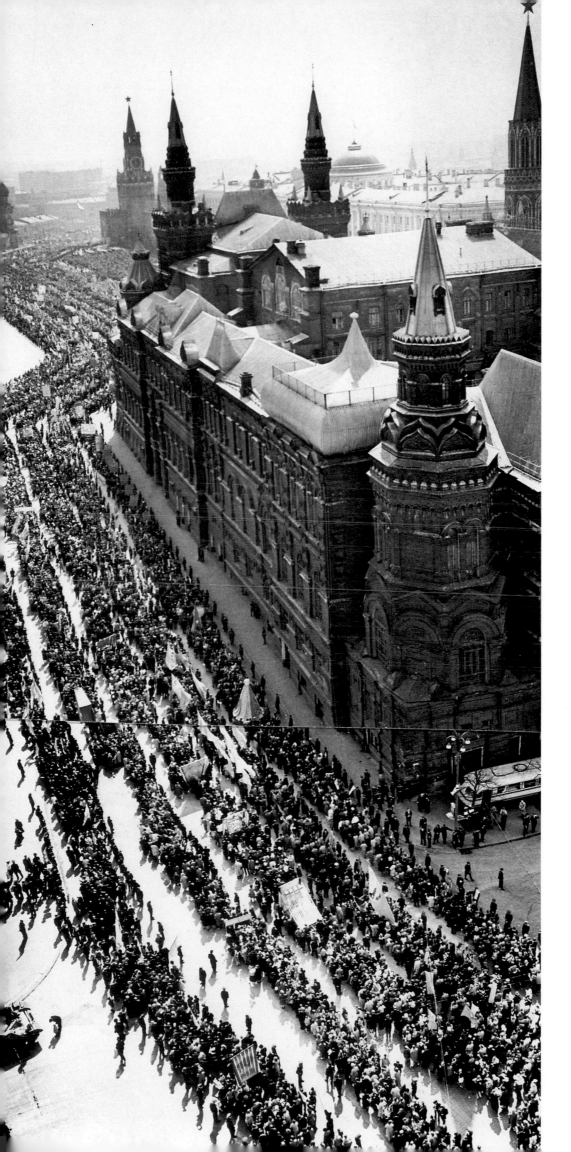

*THIS BOOK
WAS MADE
POSSIBLE
THROUGH
GENEROUS
DONATIONS
FROM:*

*H. GERALD
NORDBERG, JR.
AND
LINDA
NORDBERG*

*COLGATE
UNIVERSITY*

*LaSALLE
NATIONAL BANK*

AUTHORS' ACKNOWLEDGMENTS We have many people to thank in making this book a reality. Jane Pinchin, Dean of the Faculty at Colgate, showed, as always, extraordinary generosity and imagination. She and Dewey Mosby, Director of Colgate's Picker Art Gallery, were behind the project from its very beginnings. Gerry and Linda Nordberg, supporters in so many ways, were present at the opening of the Picker exhibition; their patience and enthusiasm have been unwavering. Herb Kahn, Art Curator of the LaSalle National Bank, flew in from Chicago to see the show and has shared his friendly advice with us ever since. As the project developed, Colgate President Neil Grabois and Bob Tyburski, Vice President for Development and Alumni Affairs, stepped in with crucial organizational and financial support.

At Aperture, Michael Hoffman had the vision to go forward with the book. Our skillful editor Michael Lorenzini steered the project from the opening negotiations through and beyond a tight production schedule. Diana Stoll's perceptive editorial work has improved the text on every page.

Special thanks go to Mr. Khaldei's daughter and son-in-law, Anna and Yury Bibichev. Anna has accompanied her father on all his recent travels, and both Anna and Yury work constantly behind the scenes to keep things going in Moscow. But our deepest gratitude is to Yevgeny Ananievich himself. Always responsive, always ready with a new story, he labored tirelessly in the darkroom and answered innumerable questions across the Atlantic.

Library of Congress Catalog Card Number: 97-73708
Hardcover ISBN: 0-89381-738-4

Printed and bound by Everbest Printing Co. Ltd., Hong Kong
Separations by Becotte & Gershwin

The Staff at Aperture for *Witness to History: The Photographs of Yevgeny Khaldei* is:
Michael E. Hoffman, *Executive Director*
Michael Lorenzini, *Editor*
Diana C. Stoll, *Copy Editor*
Stevan A. Baron, *Production Director*
Helen Marra, *Production Manager*
Maura Shea, *Editorial Assistant*
Serena Park, *Production Work-Scholar*

Aperture Foundation publishes a periodical, books, and portfolios of fine photography to communicate with serious photographers and creative people everywhere. A complete catalog is available upon request. Address: 20 East 23rd Street, New York, New York 10010. Phone: (212) 598-4205. Fax: (212) 598-4015. Toll-free: (800) 929-2323.

Aperture Foundation books are distributed internationally through: CANADA: General Publishing, 30 Lesmill Road, Don Mills, Ontario, M3B 2T6. Fax: (416) 445-5991.
UNITED KINGDOM: Robert Hale, Ltd., Clerkenwell House, 45-47 Clerkenwell Green, London EC1R OHT. Fax: 171-490-4958.
CONTINENTAL EUROPE: Nilsson & Lamm, BV, Pampuslaan 212-214, P.O. Box 195, 1382 JS Weesp, Netherlands. Fax: 31-294-415054.

For international magazine subscription orders for the periodical *Aperture*, contact Aperture International Subscription Service, P.O. Box 14, Harold Hill, Romford, RM3 8EQ, England. Fax: 1-708-372-046.
One year: £30.00. Price subject to change.

To subscribe to the periodical *Aperture* in the U.S.A. write Aperture, P.O. Box 3000, Denville, NJ 07834. Tel: 1-800-783-4903. One year: $40.00.

First edition
10 9 8 7 6 5 4 3 2 1